A POSTCARD
FROM THE
LAKE
DISTRICT

KEITH TURNER & JAN DOBRZYNSKI

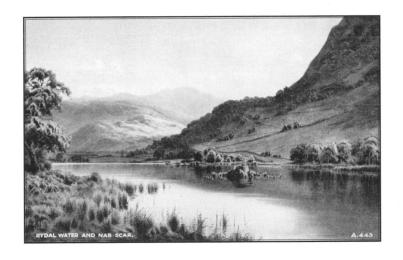

RYDAL WATER AND NAB SCAR. A.443

First published 2011

The History Press
The Mill, Brimscombe Port
Stroud, Gloucestershire, GL5 2QG
www.thehistorypress.co.uk

British Library Cataloguing in Publication Data.
A catalogue record for this book is available from the British Library.

ISBN 978 0 7524 5626 3

Typesetting and origination by The History Press
Printed in Great Britain

Contents

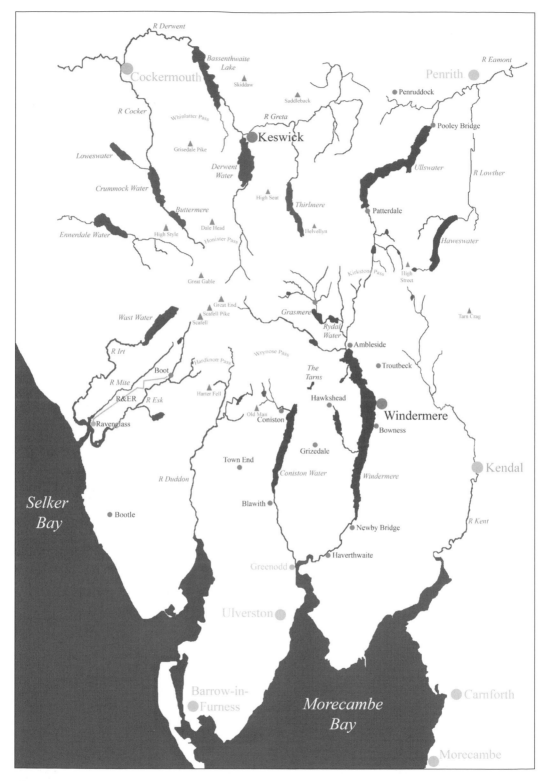

The major lakes, peaks, passes and towns of the Lake District. Names in grey denote places outside the National Park boundary.

Introduction

'A sort of national property, in which every man has a right and interest who has an eye to perceive and a heart to enjoy.'

So wrote the future Poet Laureate William Wordsworth (1770–1850) in his *Guide to the Lakes* (the abbreviated title of an immensely popular work that began life in 1810 as *A Description of the Scenery of the Lakes in the North of England* and went through five editions by 1835), expressing the desire that the beauty of his beloved Lake District be somehow preserved for the nation – and in 1951, a century after his death, it was, as England's largest and perhaps best-loved National Park. The coming of the railways from the 1840s onwards brought the Lake District within the affordable reach of the masses – incidentally a development deplored by Wordsworth for, truth be told, he had the rather snobbish attitude (but typical of his time) that only persons of a certain refinement should be allowed to appreciate their beauty, or indeed would be able to. The gates were now metaphorically open, however, and by early the

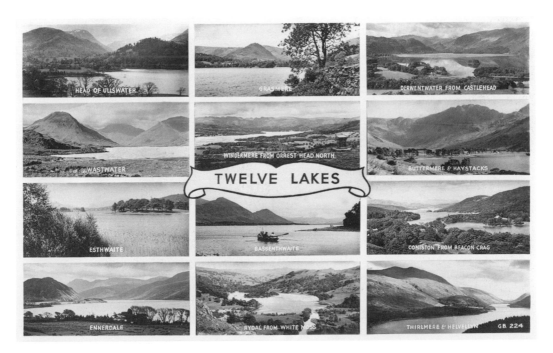

Twelve lakes – or are there? Other publishers have issued similar postcards, but with differing numbers claimed! The four lakes omitted here from the modern accepted list of sixteen are Haweswater, Crummock Water, Loweswater and Elterwater. *(Chadwick Studio Production Ingram View, Leeds 11)*

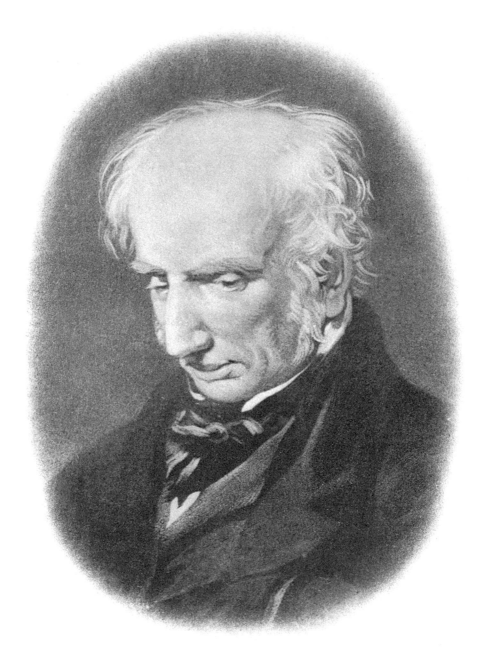

The literary figure everyone associates with the Lake District above all others – the Poet Laureate, William Wordsworth. *(Publisher unidentified)*

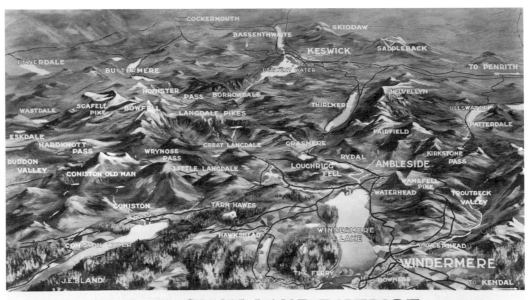

A retouched aerial photograph giving a bird's-eye view of virtually the whole of the Lake District, looking northwards, showing clearly how the lakes radiate out from the central region. (*Sanderson & Dixon, Ambleside*)

next century the astonishing popularity of the souvenir postcard saw pictures of the lakes, fells and mountains winging their way to all parts of the country – and beyond – enticing ever more visitors to come and enjoy them at first hand.

This book takes the reader on a journey in words and pictures clockwise around the Lake District, within the boundary of the National Park and with Wordsworth's beloved Grasmere as its centre, using postcard images captured by photographers and artists in the hundred years after his death and, where appropriate, quotations from the great poet and his fellow writers. The modern convention is that there are sixteen lakes, each identified by a 'water' or 'mere' component in its name (only one is officially a 'lake') to distinguish them from the smaller tarns, though, confusingly, the smallest of the lakes is smaller than the largest tarns – some of which carry the name 'water'!

All the postcards included in this book are from the authors' collections. Publication details are given at the end of the captions, if and as they appear on the cards.

Lakeland place-names have often been inconsistent as regards their spelling over the years; here they have been given their current form, except when quoted in context.

FURNESS RAILWAY.

20 COACH & STEAM YACHT TOURS
Through Lakeland.

DAILY during JUNE, JULY, AUGUST, and SEPTEMBER.

No. 1. **Outer Circular Tour**, embracing Windermere Lake, Furness Abbey, and Coniston.

No. 2. **Inner Circular Tour**, embracing Furness Abbey, Coniston Lake (Gondola) and Crake Valley.

No. 3. **Grange Circular Tour**, embracing Grange, Kendal, and Windermere Lake.

No. 4. **Middle Circular Tour**, embracing Windermere Lake, the Crake Valley and Coniston

No. 5. **Red Bank and Grasmere Tour**, via Ambleside and Skelwith Force. [Lake.

No. 6. **Thirlmere, Grasmere, and Windermere Tour**, via Ambleside, Clappersgate and Red Bank.

No. 7. **The Four Lakes Circular Tour**, viz.—Coniston, Grasmere, Rydal & Windermere.

No. 8. **Coniston to Coniston Tour**, via Red Bank, Grasmere and Ambleside.

No. 9. **Tarn Hows Tour**, via Ambleside and Coniston, returning by Tilberthwaite and Elterwater.

No. 10. **Round the Langdales and Dungeon Ghyll Tour**, via Ambleside, Colwith Force, Grasmere and Rydal.

No. 11. **Ullswater Tour**, via Ambleside, Kirkstone Pass and Brothers Water, returning via the Vale of Troutbeck and Lowwood.

No. 12. **Derwentwater (Keswick) Tour**, via Ambleside, Grasmere and Thirlmere.

No. 13. **The Five Lakes Circular Tour**, viz.—Windermere, Grasmere, Rydal, Thirlmere

No. 14. **Wastwater Tour**, via Seascale and Gosforth. [and Keswick.

No. 15. **The Six Lakes Circular Tour**, viz.—Windermere, Rydal, Grasmere, Thirlmere, Derwentwater and Ullswater.

No. 16. **The Duddon Valley Tour**, via Broughton-in-Furness, Ulpha and Seathwaite.

No. 17. **Levens and Heversham Tour**, via Grange, Milnthorpe and Arnside.

No. 18. **Ennerdale Lake and Calder Abbey Tour**, via Seascale, Gosforth & Cold Fell.

No. 19. **Across The Ferry Tour**, via Esthwaite Water, Hawkshead, Ferry & Storrs Hall.

No. 20. **Cartmel Priory and Newby Bridge Tour**, via Windermere (Lake Side), Holker Park and Grange.

For further particulars see "TOURS THROUGH LAKELAND" *Pamphlets, to be had gratis at all Furness Railway Stations; of* Mr. F. J. Ramsden, *Superintendent of the Line, Barrow-in-Furness; at* Messrs. Thos. Cook & Sons *and* H. Gaze & Sons' *Offices, and the* Polytechnic Institute (*Regent Street, W.*), *or* Messrs. W. H. Smith & Sons' *principal Bookstalls, price ½d.*

The NEW PALETTE ALBUM, illustrating the above Tours, in Colours, can be obtained at the principal Railway Bookstalls, price 6d.

ALFRED ASLETT,
Secretary and General Manager.

Barrow-in-Furness, April, 1901.

In the late Victorian and the Edwardian eras the railway company serving the south-western part of the Lake District, with a long coastal route and branches inland to Windermere and Coniston Water, was the Furness Railway. This is one of its advertisements from *Miller's Official Tourist Guide to the North British Railway* of 1901 for its many combined coach and steamer tours around all parts of the Lake District and its fringes.

1

Windermere &
Esthwaite Water

A pleasant sight it was when, having clomb
The Heights of Kendal, and that dreary Moor
Was crossed, at length, as from a rampart's edge,
I overlooked the bed of Windermere.
I bounded down the hill, shouting amain
A lusty summons to the farther shore
For the old Ferryman; and when he came!
Did not step into the well-known Boat
Without a cordial welcome.

(William Wordsworth, 'The Prelude' Book 4)

(Chadwick Studio Productions 491 Oakwood Lane, Leeds 8)

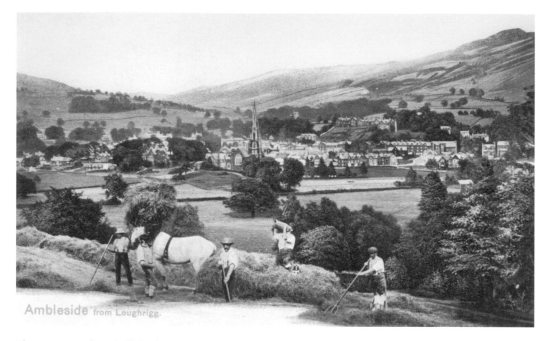

The most popular of all the lakes, in terms of visitor numbers, is undoubtedly Windermere. It is also for many, because of its eastern location and good road and rail links, the first they reach from elsewhere in England. A little to the north of its head is the town of Ambleside. *(Peacock Brand)*

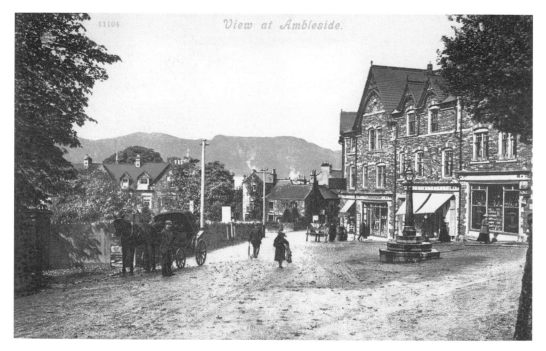

The central crossroads in Ambleside, on the main road from Windermere to Rydal Water and Grasmere, looking north-westwards towards the central fells. *(Publisher unidentified)*

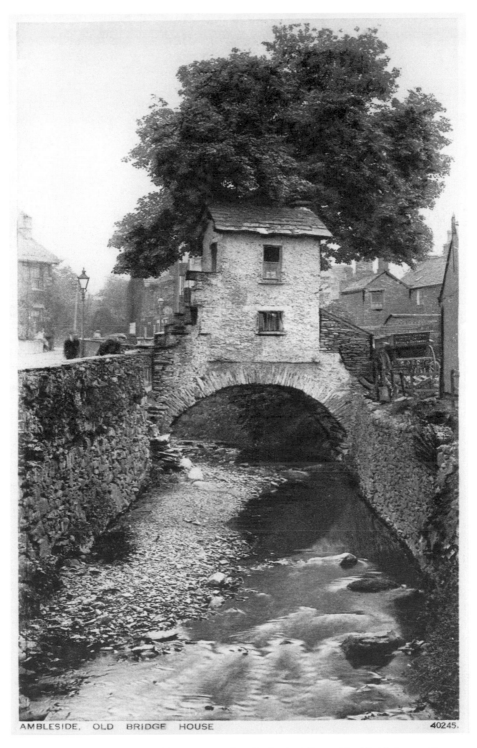

AMBLESIDE, OLD BRIDGE HOUSE 40245.

Flowing through the centre of the town and under Bridge House (Ambleside's most famous – and most photographed – building) is the Stock Beck. Once Ambleside Hall's apple store, Bridge House is now a National Trust information centre. *(Photochrom Co. Ltd, London and Tunbridge Wells)*

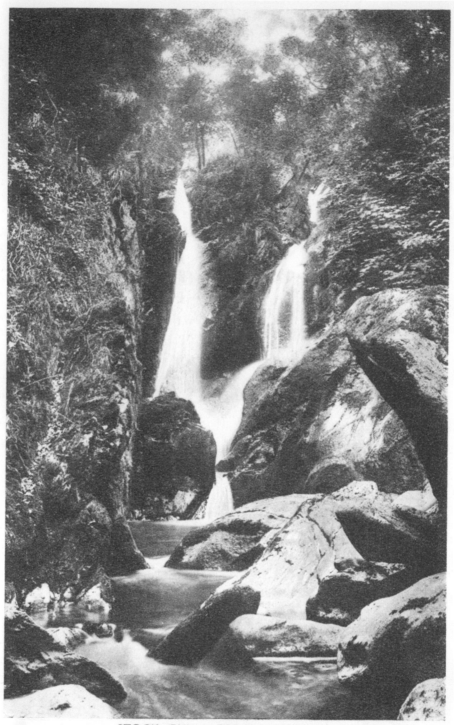

STOCK GHYLL FORCE, AMBLESIDE

A 1943-franked card of Stock Ghyll Force, a noted beauty spot half a mile north of the town. Both 'ghyll' and 'force' are from Old Norse, meaning 'ravine' and 'waterfall' respectively, and are commonly found in names across the Lake District. *(G.P. Abraham Ltd. Keswick)*

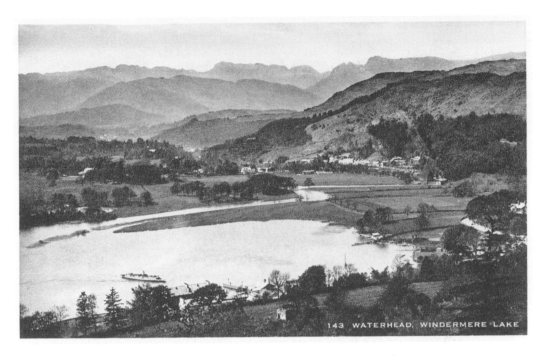

143 WATERHEAD, WINDERMERE LAKE

Southwards, Ambleside merges with the district of Waterhead at Windermere's northernmost tip. *(Photogravure Series by G.P. Abraham Ltd. Keswick)*

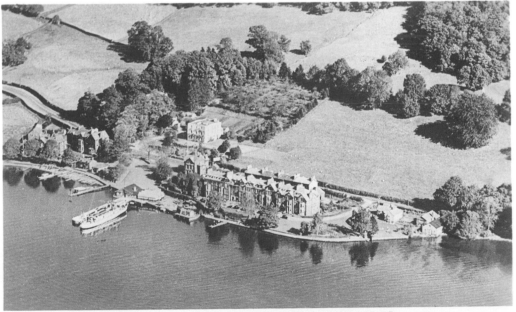

7625. AMBLESIDE. WATERHEAD, HOTELS AND LANDING STAGE.

The landing stage for the Windermere pleasure steamers at Waterhead, on the eastern shore of the lake, on a 1950s card – before the grand hotels here were encroached upon by residential and other development. *(Aero Pictorial Ltd, 137, Regent Street, London, W.1)*

An advertisement for the three principal hotels at Ambleside, and for associated coach tours to neighbouring parts (still horse-drawn at this date), again from *Miller's Official Tourist Guide to the North British Railway*, 1901 edition.

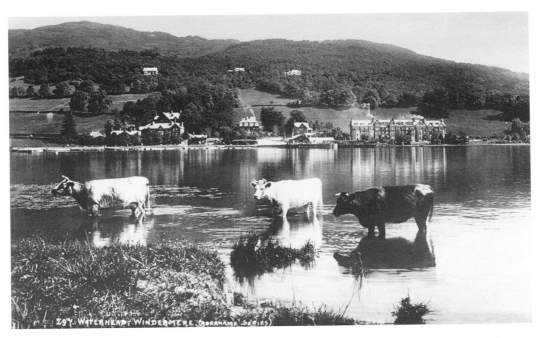

Cattle and water – always a favourite combination with postcard publishers, be it a river or, as here, a lake. (*G.P. Abraham, F.R.P.S. Keswick*)

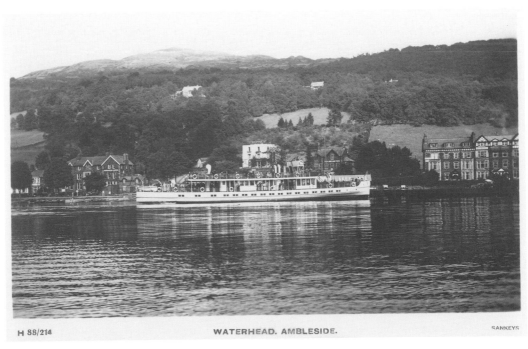

A closer view of Waterhead, with one of the lake's pleasure steamers – either the *Swan* or the *Teal* – occupying pride of place. (*Sankeys, Barrow-in-Furness*)

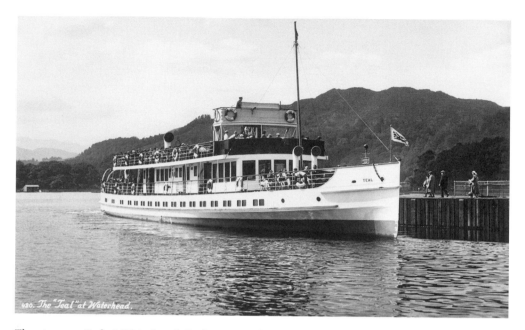

The steamer *Teal* at Waterhead. Built in 1936 by Vickers-Armstrong of Barrow-in-Furness for the London, Midland & Scottish Railway's lake fleet, she is still in service today. Although always diesel-powered, she continues the tradition of the Windermere steamers by always being referred to as such. *(Publisher unidentified)*

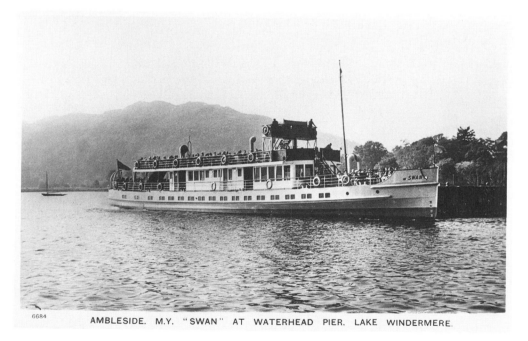

Sister vessel to the *Teal*, the *Swan* is just two years younger and also still in service on the lake. Each with a length of 138ft and a beam of 25ft, they are the largest such vessels operating on inland waters in England, the current owners being Windermere Lake Cruises Ltd of Bowness. *(Aero Pictorial Ltd., 137, Regent Street, London, W.1)*

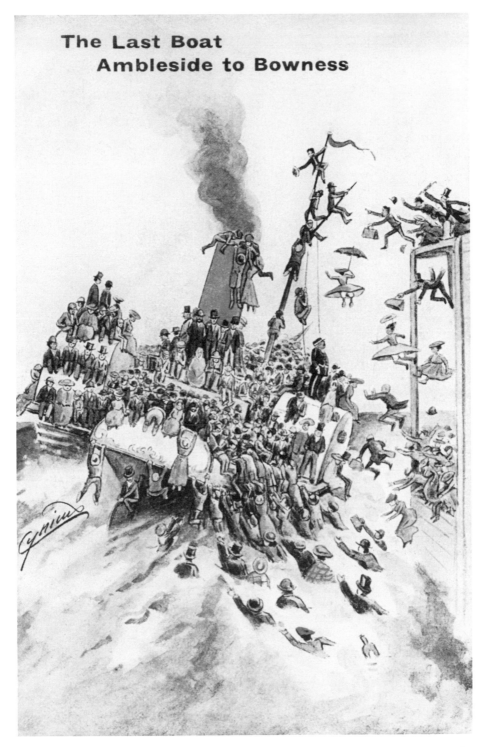

All forms of transport have been considered fair game by publishers of comic postcards, who often kept costs to a minimum by using the same artwork overprinted with different captions, as here, for sale in different localities. The sender, in 1910, has commented: 'True to life!' *(The Cynicus Publishing Co. Ltd., Tayport, Fife)*

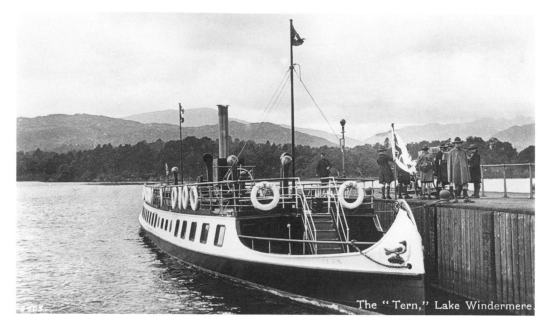

The " Tern," Lake Windermere

Far older than either the *Swan* or the *Teal* (and somewhat smaller at 100ft by 14ft) is the twin-screw steamer *Tern*, built in 1891 by Forrest of Wivenhoe, Essex, for the LMS's predecessor, the Furness Railway. She is the oldest vessel in the Windermere fleet, and was converted from steam to diesel propulsion in 1958. Note her distinctive canoe stem, still intact today. *(Salmon Series J. Salmon Ltd., Sevenoaks, England)*

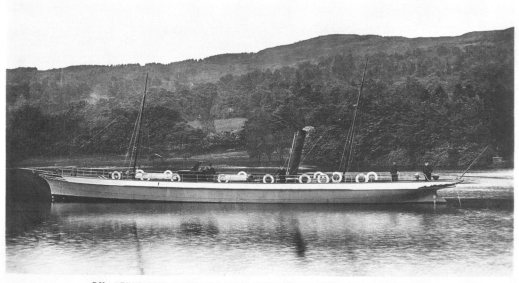

S.Y. "BRITANNIA" FOR HIRE BY PRIVATE PARTIES ON WINDERMERE COPYRIGHT

Sadly no longer in service, having been scrapped in 1919, is the steam yacht *Britannia*, built by T.B. Seath & Co. of Rutherglen in 1879 for a Colonel Ridealgh of Lakeside, then acquired by the Furness Railway in about 1907 and used by its directors and, as this card advertises, hired out for private parties. *(Raphael Tuck & Sons, Ltd., for the Furness Railway Railway "English Lake Steamers" Series No. 10)*

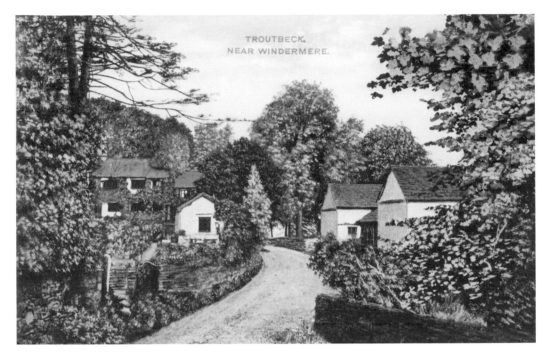

About 2 miles due east of Waterhead, on the other side of Wansfell, is the village of Troutbeck, strung out along the main road (now the A592) from Windermere to the north via the Kirkstone Pass. *(The Star Series – G.D. & D. – London)*

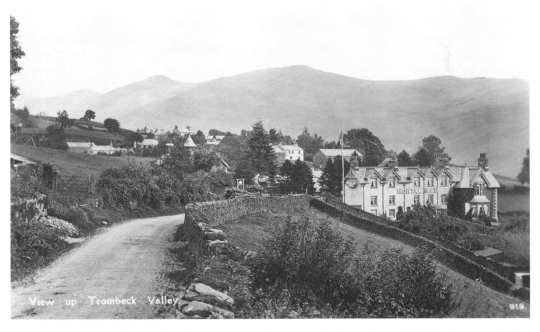

Troutbeck again, in its beautiful valley setting. On the right is the Mortal Man Hotel, its sign proclaiming: 'O mortal man that lives by bread,/ What is it makes thy nose so red?/ Thou silly fool that looks so pale,/ 'Tis drinking Sally Birkett's ale.' *(Atkinson & Pollitt, Kendal)*

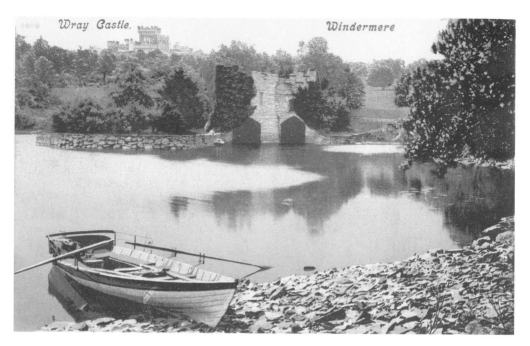

Between Waterhead and where the Trout Beck enters Windermere, on the opposite side of the lake stands Wray Castle, a National Trust property currently not often open to the public (though the gardens are). It was constructed in 1849 as a Gothic extravaganza – apparently for a gin heiress who then adamantly refused to live in it! *(Publisher unidentified)*

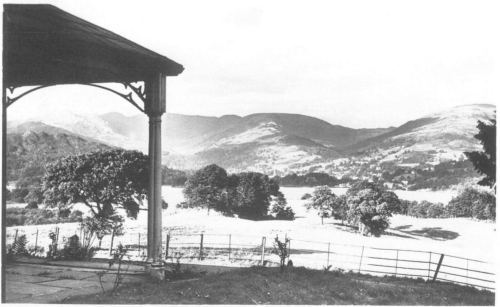

VIEW FROM THE DOWER HOUSE, WRAY CASTLE S.777

The view from Wray Castle across the head of Windermere. Beatrix Potter (see pages 34 and 35) stayed here, aged sixteen, when her father rented it for a holiday – the first of several holidays in the Lakes and the beginning of her life-long love affair with the region. *(Sanderson & Dixon, Ambleside)*

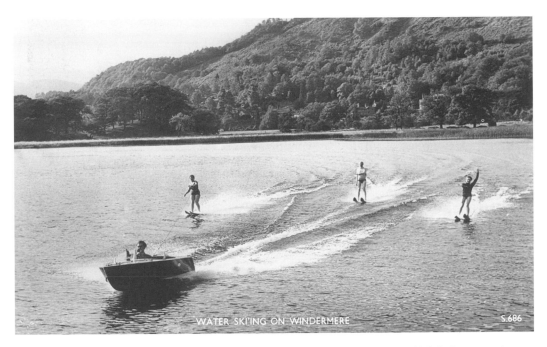

A far cry from the peaceful atmosphere of the previous cards! Thankfully, the selfish behaviour of some lake users as portrayed in this 1950s scene cannot be witnessed today, as a 10-knot speed limit was imposed in 2005 in an effort to restore some measure of tranquility to England's largest lake. *(Sanderson & Dixon, Ambleside)*

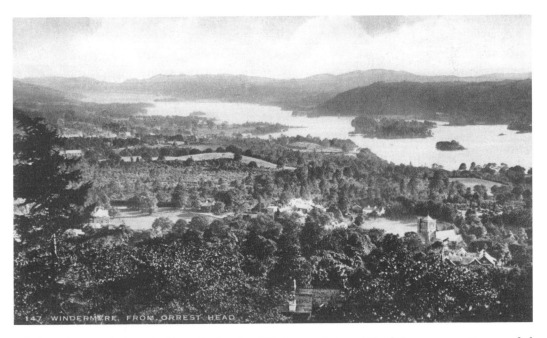

A little to the east of where the Trout Beck enters Windermere is Orrest Head. Its easy ascent is rewarded with views in all directions, including the northern half of the lake and the modern town of Windermere centred around the railway station (opened 1847) a little way inland. *(G.P. Abraham, Ltd. Keswick)*

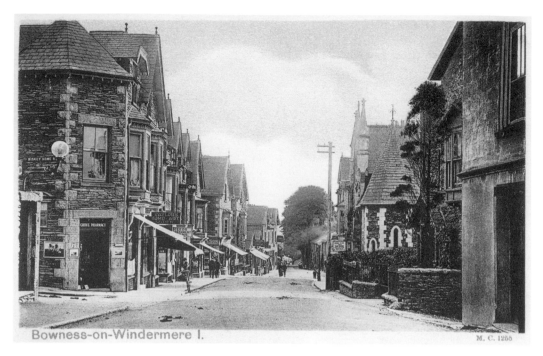

The principal settlement on Windermere is Bowness-on-Windermere (generally shortened to simply Bowness), south of the modern housing of Windermere town. This is the main (A5074) through road leading down to meet the lake by the landing stages, on a 1907-franked card. *(Peacock "Stylochrom" Post Card. The Pictorial Stationery Co., Ltd., London)*

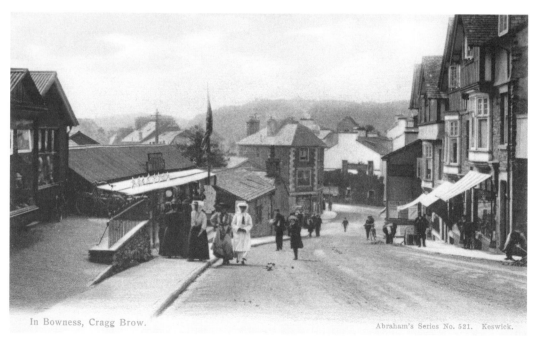

One of the side roads in Bowness, looking westwards down to its junction with the main road shortly before it reaches the lake, on a card of the same period. *(Abraham's Series No. 521. Keswick)*

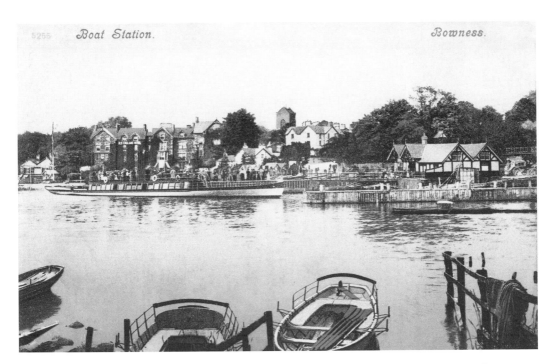

The centre of Bowness, as far as most tourists are concerned: the 'Boat Station' with its landing stages where boats large and small wait to take them out onto the water. *(Publisher unidentified)*

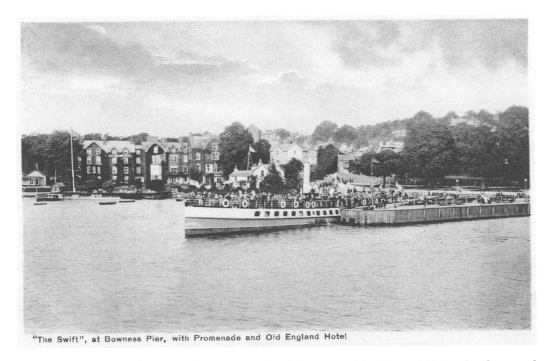

Another ex-Furness Railway vessel now operated by Windermere Lake Cruises Ltd: the diesel-powered *Swift*. It was built in 1901 by Seath of Rutherglen as a steamer but converted in 1956 by British Railways (successor to the LMS). At 150ft long and 21ft wide she is longer and narrower than the *Swan* and the *Teal*, though has the same maximum speed of 12mph. *(Publisher unidentified)*

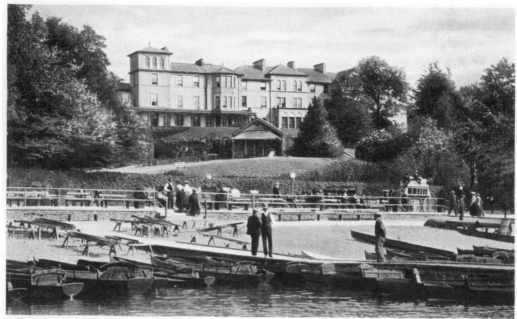

Belsfield Hotel from Windermere.

The Boat Station bay at Bowness is ringed by grand hotels, including the Belsfield in central pride of place, seen here from the lake on a 1906-franked card. *(Peacock "Autochrom" Post Card. The Pictorial Stationery Co., Ltd., London)*

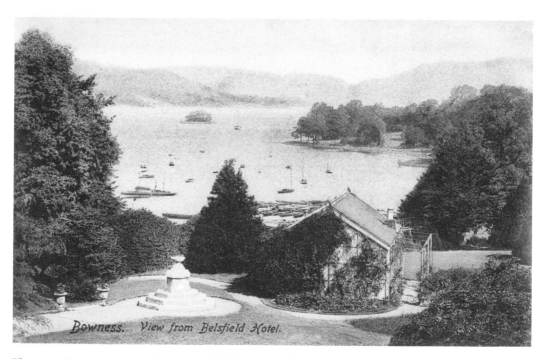

Bowness. View from Belsfield Hotel.

The magnificent view west from the Belsfield, on a card posted just four years later but not so different from today's vista. *(Frith's Series)*

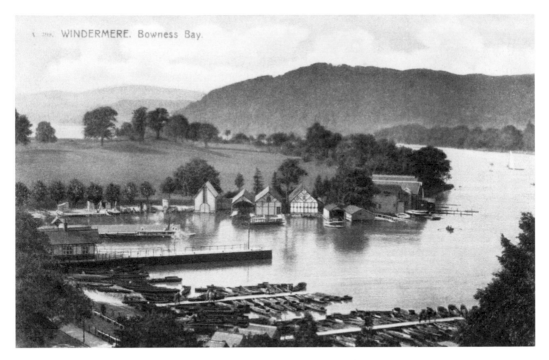

Looking south across Bowness Bay, to the steamer piers beyond the rowing boats for hire . . . *("Pictochrom" Post Card. The Pictorial Stationery Co. Ltd., London)*

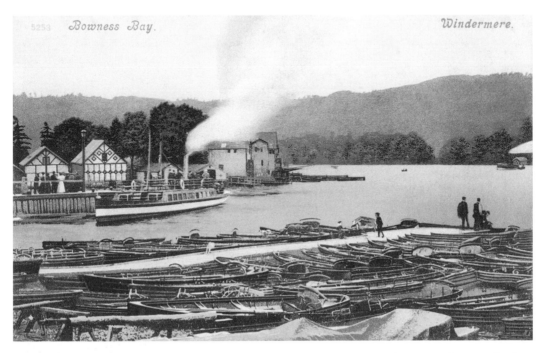

. . . and an even closer view over the moored skiffs, with the Furness Railway's steamer the *Swan*, built in 1869 by Seath, by the jetty. She was scrapped in 1938 and her name taken by the present *Swan*. (*Publisher unidentified*)

An artist's rendering of the view northwards from below Bowness Bay (out of sight to the right), with the southern end of Belle Isle in the centre of the painting, on an official London & North Western Railway postcard – this company owned the branch to Windermere just to the north. *(McCorquodale & Co., Limited)*

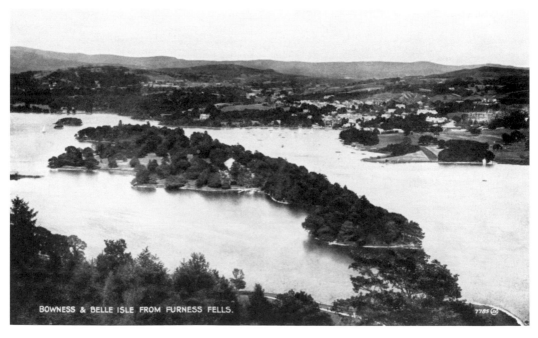

Belle Isle from the west, with Bowness Bay just right of centre. Privately owned (and inhabited), the island is by far the largest such feature in Windermere. *(Valentine's "Silveresque" Postcards. Valentine & Sons, Ltd., Dundee and London)*

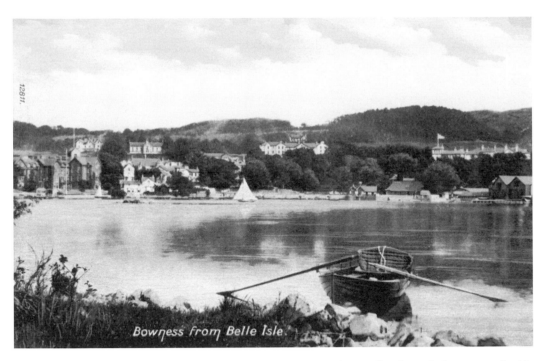

Looking across the narrow stretch of water separating Bowness from Belle Isle, with the unmistakeable bulk of the Old England Hotel far left. *(The Wrench Series No. 12811)*

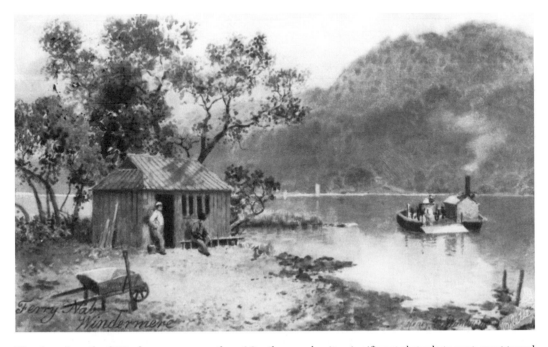

The sheer length of Windermere – more than 10 miles – makes it a significant obstacle to east–west travel in the eastern Lake District. Luckily, a very convenient narrowing of the lake at its mid-point has provided the perfect location for a ferry across it. *("Picturesque English Lakes." – H.B. Wimbush. Raphael Tuck & Sons' "Oilette" Postcard 7286)*

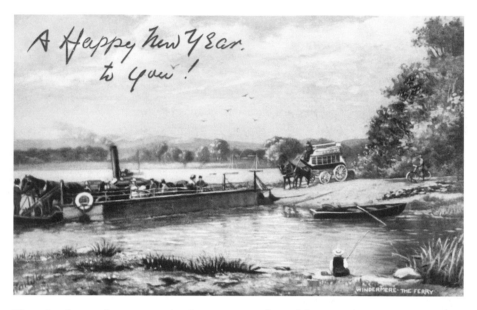

There has been a ferry across Windermere since the Middle Ages; the original succession of (very large) rowed boats that Wordsworth knew were replaced in 1870 by the steam-powered vessel seen here (and in the previous view). Note the New Year's greeting overprinted on this 1906-franked postcard – a common publisher's device to try to increase sales at a slack time of the year. (*Wordsworth's Country – "Windermere." Raphael Tuck & Sons' "Oilette" Postcard 7314*)

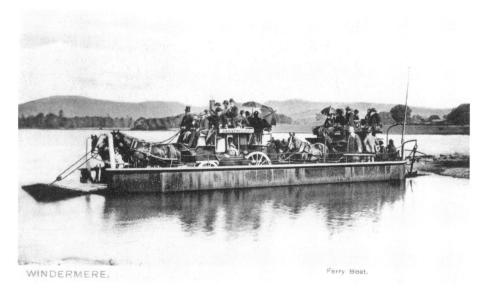

An excellent photographic view of the steam ferry, laden with two coaches (one signed for Coniston) and their host of passengers. A steam engine on the far side of the boat powered winding wheels around which was looped a wire cable, tethered to both banks, so enabling the boat to winch itself across the lake. The cable was slack enough to drop to the lake bottom after the boat had moved on, allowing other vessels to pass over it. (*Peacock Brand "Platino-Photo" Postcard. Pictorial Stationery Co., Ltd. London*)

THE FERRY HOTEL Herbert & Sons, Photographers, Windermere

The western terminal of the ferry is known as Ferry House, after the original waiting room for passengers. The original Ferry Inn close by was demolished in 1879 and the one seen here erected; this in turn was sold in 1948 to become the Windermere headquarters of the Freshwater Biological Association. *(Herbert & Sons, Windermere)*

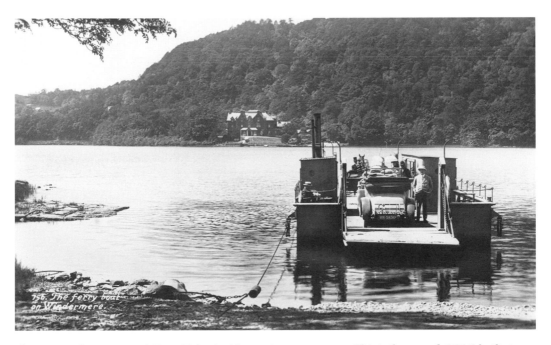

The eastern ferry terminal, Ferry Nab – 'nab' meaning promontory. This is the second, 1915-built steam ferry, with a car and a horse carriage on board in the days when both modes of transport co-existed on the roads . . . *(G.P. Abraham, Ltd. Keswick)*

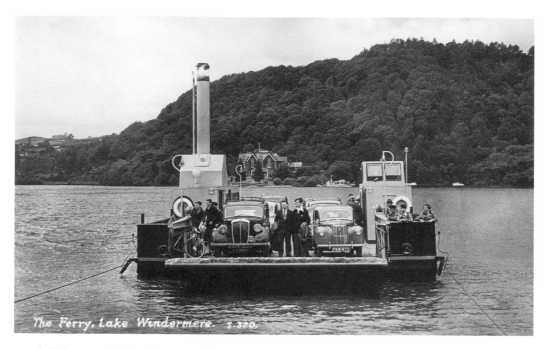

The Ferry. Lake Windermere. s.320.

. . . while this is its 1954 replacement, the *Drake*. She was converted to diesel power in 1960 and scrapped thirty years later, to be replaced by the present-day vessel the *Mallard. (Sanderson & Dixon, Ambleside)*

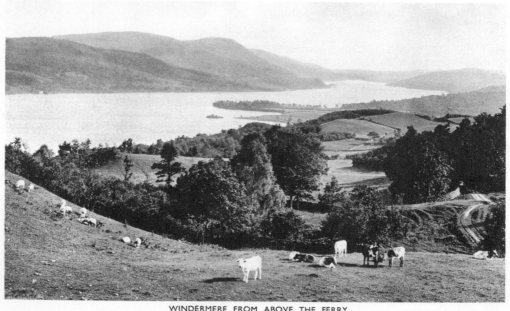

WINDERMERE FROM ABOVE THE FERRY

Looking southwards down the lake, with the peninsula (centre picture) marking the site of the western ferry terminal. The small island immediately below it is Crow Holme, from the Old English 'holm' meaning island. *(Photogravure Series by G.P. Abraham, Ltd. Keswick)*

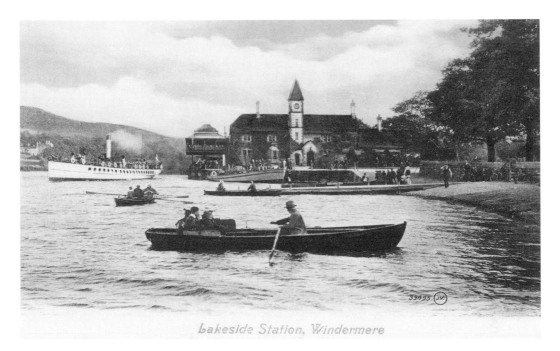

Lakeside Station, Windermere

At the very southern end of Windermere is the settlement of Lakeside, a landing place for the tourist steamers from Bowness and Ambleside (and a place to stay on holiday in its own right). The grand building known as the Pavilion shields the railway station beyond. *(Valentine's Series)*

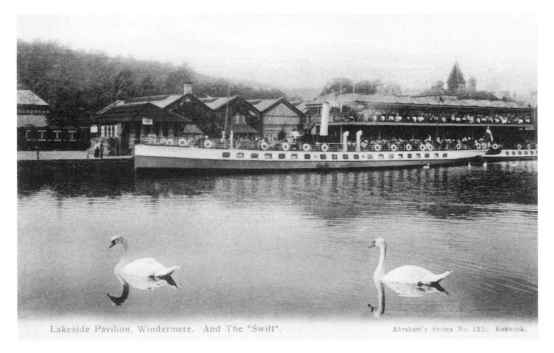

Lakeside Pavilion, Windermere. And The "Swift". Abraham's Series No. 522. Keswick.

The Pavilion in a side-on view, with the railway station to the left. From here a Furness Railway branch, opened in 1869, ran south-westwards to join the main coastal line near Ulverston. *(Abraham's Series. No. 522. Keswick)*

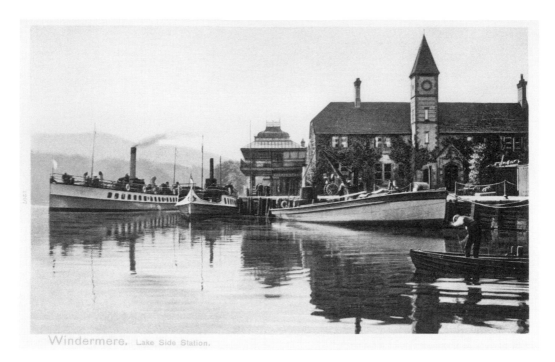

A busy scene at the various Lakeside landing stages, with the *Swift* leaving for a return trip up the lake. *("Autochrom" (Colour Photo) Postcard. Pictorial Stationery Co. Ltd., London)*

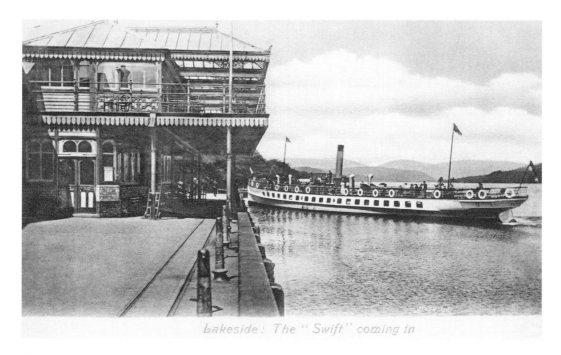

The *Swift* at Lakeside again, this time arriving with its complement of tourists. Note the section of narrow gauge railway along the quayside, used for moving passengers' luggage and the like. This line has since been lifted, but a section of the standard gauge branch, from Lakeside down to Haverthwaite, is now a preserved steam railway attracting many thousands of visitors a year. *(Valentine's Series)*

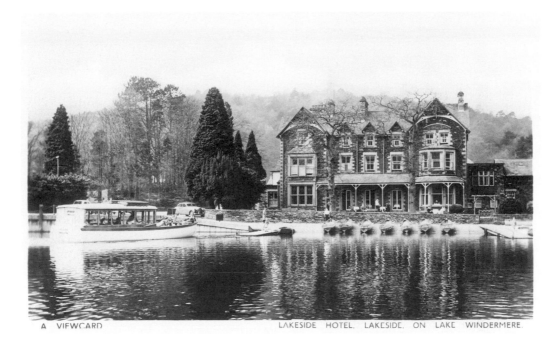

Where some of that luggage would have been carried: the elegant Lakeside Hotel by the steamer terminal, looking much as it appears today. *(View Card Issuing Co. Ltd. Manchester)*

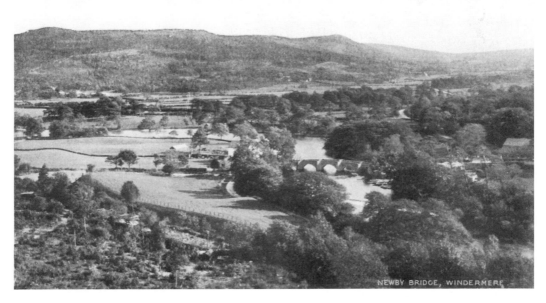

Beyond Lakeside, Windermere is drained by the River Leven, the first crossing point of which is at Newby Bridge. The view is towards the lake (hidden by the trees), and the Furness Fells. *(B & R's "Camera" Series No. 445)*

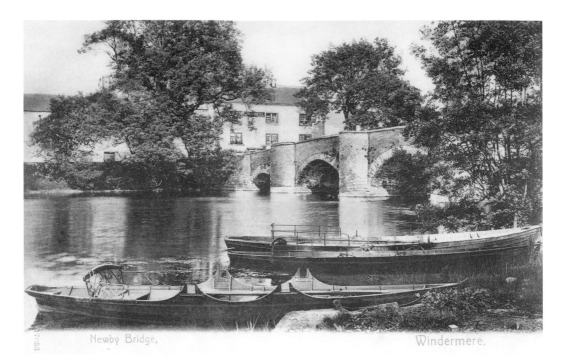

The Swan Hotel, by Newby Bridge, as seen from the southern bank of the Leven. Like the vast majority of such establishments in this collection of illustrations, the hotel is, thanks to the unending stream of visitors to the region, still very much in business today. *(Stengel & Co., London EC 39 Redcross Street)*

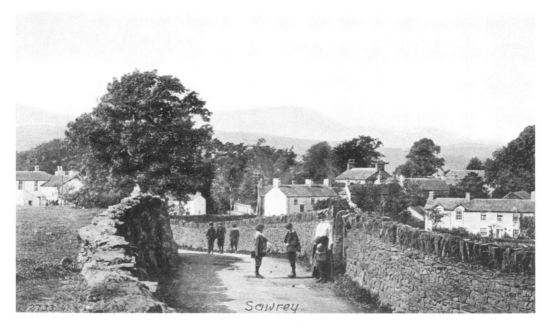

Returning back to the mid-point of the lake, west of the Windermere Ferry the road climbs up and over a long ridge to reach the neighbouring villages of Far Sawrey and then Near Sawrey, seen here. Today Near Sawrey is a major tourist destination, with the Lakeland home of the writer and illustrator Beatrix Potter (1866–1943), Hill Top, open to the public. *(Hartman's)*

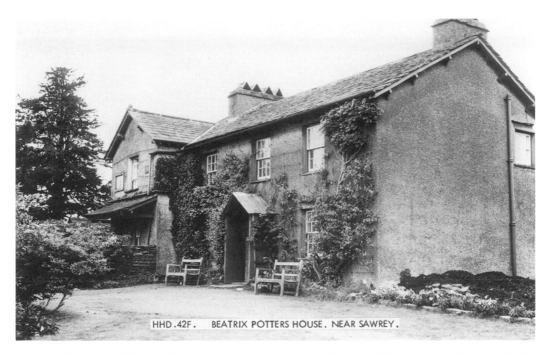

HHD.42F. BEATRIX POTTERS HOUSE. NEAR SAWREY.

Hill Top farmhouse, bought by Beatrix Potter in 1905 with the royalties from her first book, the enchanting (and now world-famous) children's story *The Tale of Peter Rabbit*. In 1913 she married a local solicitor and moved house, retaining Hill Top as her study. Upon her death the house and surrounding farmland were bequeathed to the National Trust – one of her passionate causes – and it remains just as she left it. *(Frith's Series Reigate)*

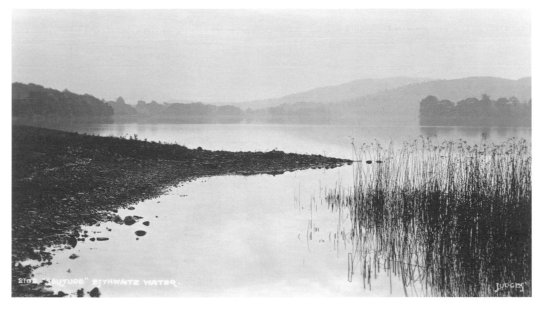

Just beyond Near Sawrey, to its west, is Esthwaite Water, a quiet little lake usually (and unjustly) overlooked by visitors to Hill Top. Of it, Wordsworth wrote in Book 2 of *The Prelude*: 'My morning walks / Were early; oft before the hours of School / I travelled round our little Lake, five miles / Of pleasant wandering, happy time!' *(Judges' Ltd. Hastings)*

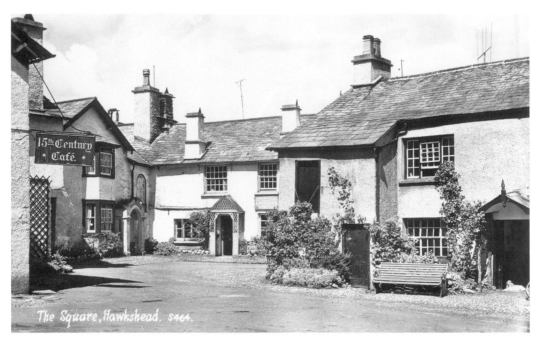

At the northern end of Esthwaite Water is the village of Hawkshead, roughly midway along the B5285 from Windermere Ferry to Ambleside. *(Sanderson & Dixon, Ambleside)*

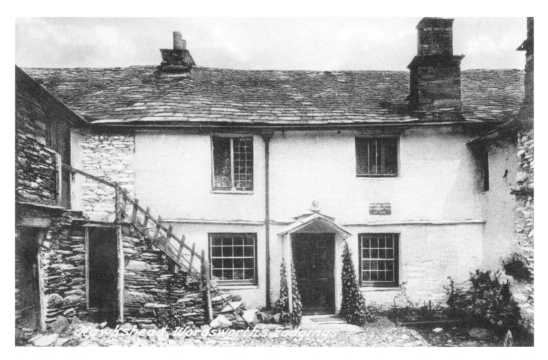

Ann Tyson's house, now a guest house, in the fittingly named Wordsworth Street (formerly Putty Street), Hawkshead. This was where the young William lodged for a while during term time when he attended the local grammar school, and it is now a museum. *(Frith's Series F. Frith & Co., Ltd., Reigate. No 30536)*

2

The Central Lakes

Thrice hath the winter moon been filled with light
Since that dear day when Grasmere, our dear Vale,
Received us; bright and solemn was the sky
That faced us with a passionate welcoming,
And led us to our threshold, to a home
Within a home, what was to be, and soon,
Our love within a love.

<div align="right">(William Wordsworth, 'Home at Grasmere')</div>

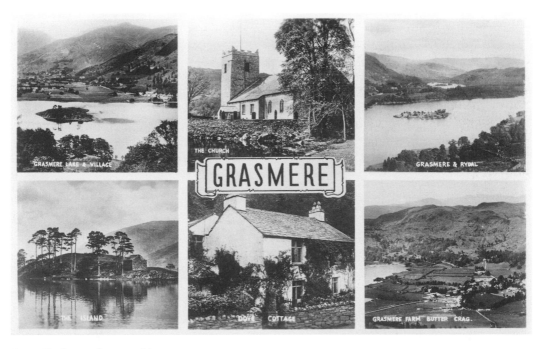

(G.P. Abraham Ltd., Keswick)

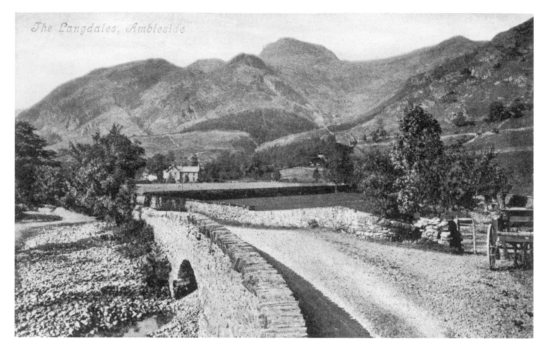

Journeying northwards from Ambleside, the traveller approaches the charming Rydal Water, with Langdale Pike glimpsed in the far distance. Here the main road – now the A591 – crosses a beck joining the River Rothay on the left. *(Valentine's Series)*

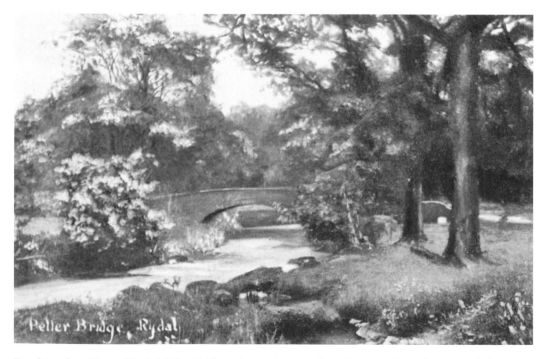

Reaching the village of Rydal, Pelter Bridge takes a minor road south across the Rothay. *(S. Hidesheimer & Co., Ldt. [sic] London & Manchester)*

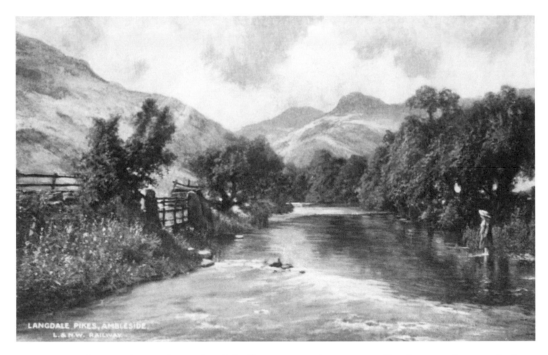

The River Rothay on the outskirts of Rydal village, on another LNWR official postcard, again looking north-westwards to Rydal Water. Many railway companies sold similar postcards, often in sets, during the early years of the twentieth century, to encourage tourists to visit the places depicted – using their trains to get there, of course! *(McCorquodale & Co., Limited)*

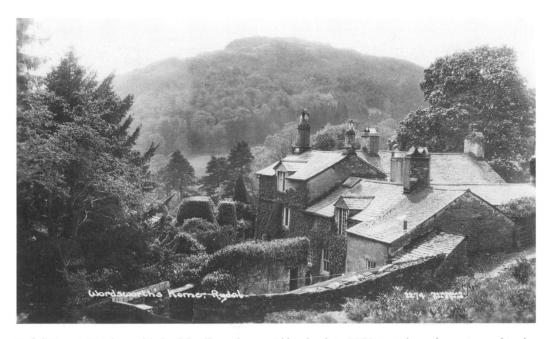

Rydal Mount, Wordsworth's final dwelling place until his death in 1850, just above the main road in the centre of the village. The building began life in the sixteenth century as a farmhouse, and is now open to the public. *(Publisher unidentified)*

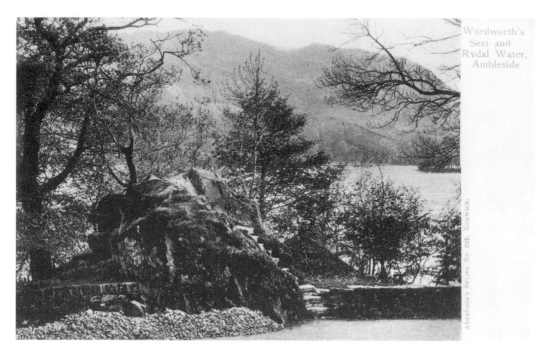

Leaving Rydal behind, between that village and Grasmere stands the rock known as Wordsworth's Seat, overlooking peaceful Rydal Water. Here the poet loved to sit in quiet contemplation – as do many of today's visitors, their climb to the top made easier by the later steps. *(Abraham's Series No. 327 Keswick)*

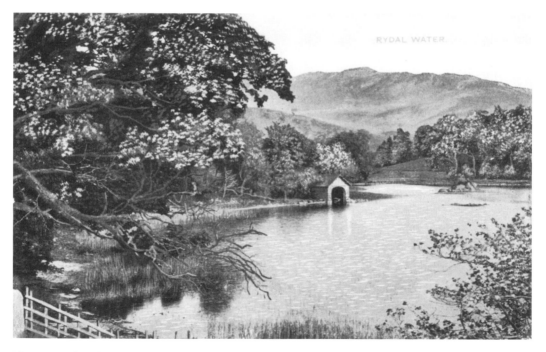

The tranquil and very pretty Rydal Water, another of the lakes often unjustly overlooked by visitors, this time as they speed past on their way to Grasmere. *(The Star Series – G.D. & D., London)*

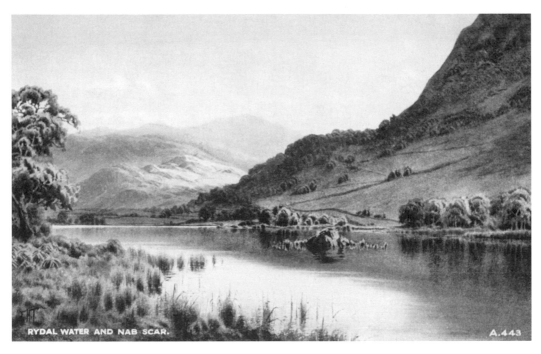

To quote the printed text on the back of this card, Rydal Water is 'One of the smallest, but probably one of the most beautiful of the Lakes' and that 'The foliage-clad shore is a blaze of colour in Autumn.' Nab Scar is the crag on the far right. *(Valentine's "Art Clear" Postcards. From an original watercolour by Edward H. Thompson. Valentine & Sons Ltd,. Dundee and London)*

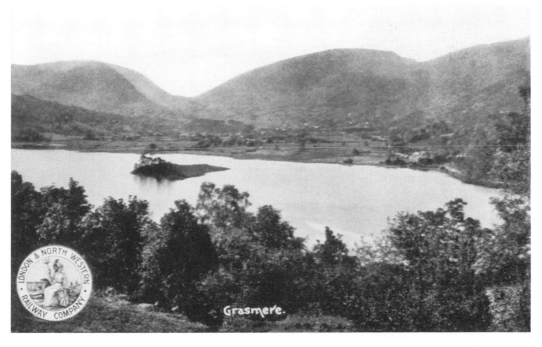

And so to Grasmere, another 2 miles on from Rydal Water and, at just a mile in length, slightly larger than its neighbour. *(McCorquodale & Co., Limited)*

LETTER CARD

OF

GRASMERE

SIX VIEWS IN SEPIA PHOTOGRAVURE

Printed
in
England

With Address and Signature only and flap tucked in, postage ½d. With writing and flap stuck down, postage 1½d

To_____

From _____

ABRAHAM'S PRIZE MEDAL SERIES (Copyright) KESWICK
ALL-BRITISH PRODUCTION

Between the First and Second World Wars there was a vogue for sending souvenir letter cards – like this one – comprised (usually) of six postcard images on a folded strip of paper inside their own envelope. *(Abraham's Prize Medal Series Keswick)*

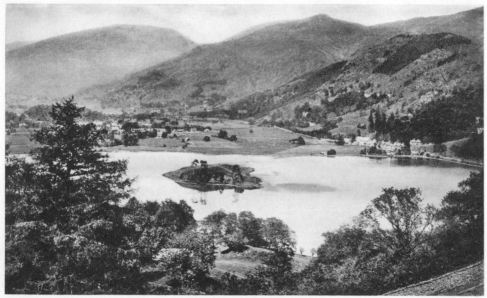

GRASMERE LAKE AND VILLAGE

The six sepia-tinted scenes contained in the Grasmere letter card (above), beginning with the view northwards across the lake to the village. Dove Cottage is in the cluster of houses on the right. *(Abraham's Prize Medal Series Keswick)*

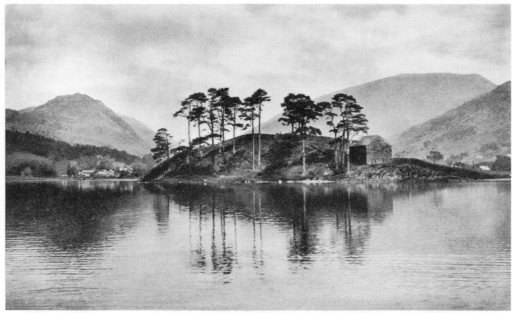

THE ISLAND. GRASMERE

Grasmere's little island, situated north of the centre of the lake. *(Abraham's Prize Medal Series Keswick)*

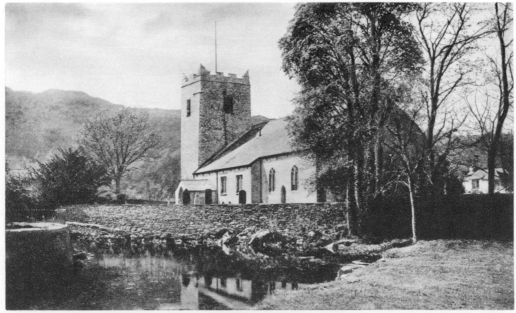

GRASMERE CHURCH

The village church, dedicated to St Oswald and dating from the thirteenth century. Its unique twin naves gave rise to Wordsworth's description of its interior, in Book 5 of *The Excursion*, as being 'With pillars crowded'. *(Abraham's Prize Medal Series Keswick)*

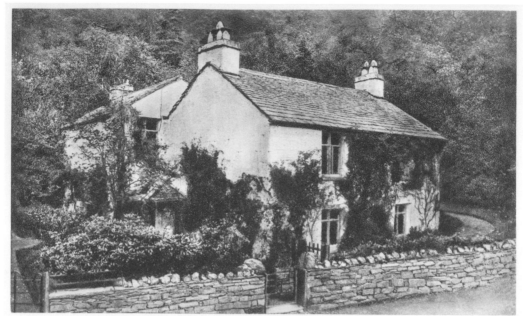

DOVE COTTAGE, GRASMERE, WORDSWORTH'S HOME

Dove Cottage, sometime home of the family Wordsworth and an image familiar from a million postcards, on the now bypassed main Ambleside to Grasmere and Keswick road. *(Abraham's Prize Medal Series Keswick)*

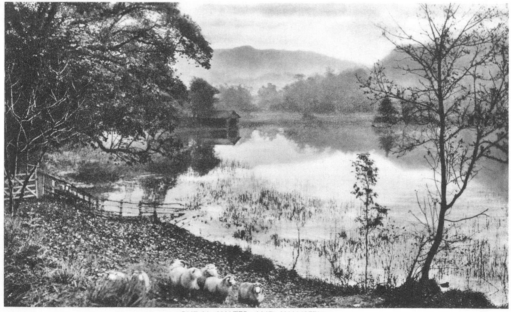

RYDAL WATER AND WANSFELL

Rydal Water – with a flock of wandering sheep, without which no romantic view of the Lakeland landscape is seemingly complete. *(Abraham's Prize Medal Series Keswick)*

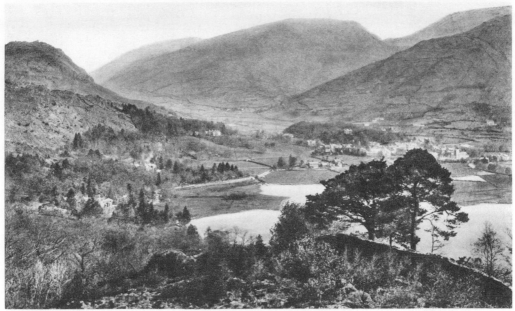

GRASMERE, FROM FIR CRAG

Grasmere again, looking north-westwards across the lake to the village. *(Abraham's Prize Medal Series Keswick)*

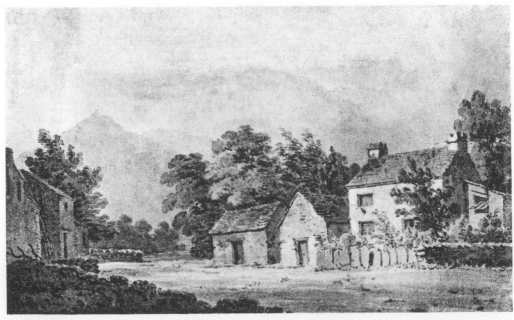

DOVE COTTAGE about 1805

An artist's impression of what Dove Cottage may have looked like not long after Wordsworth and his younger sister Dorothy first rented the premises for £8 a year in December 1799. *(Publisher unidentified)*

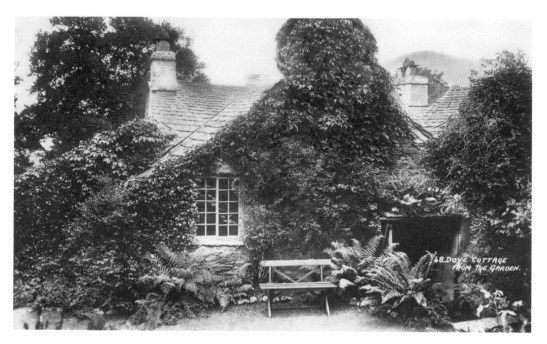

Dove Cottage – formerly the Dove & Olive-Bough Inn in the hamlet of Town End – from the rear garden. Here Wordsworth planted honeysuckle and roses to hide the whitewashed walls – a feature of the Lake District he apparently abhorred. *(G.P. Abraham, Ltd. Keswick)*

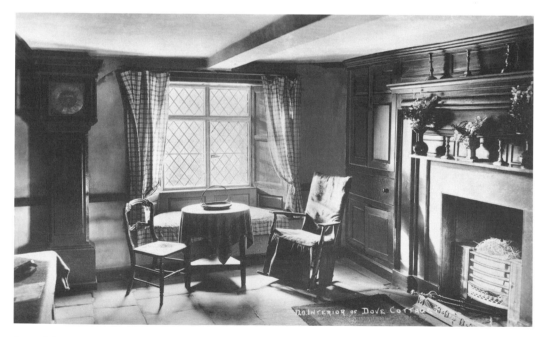

One of the downstairs rooms in Dove Cottage. In 1802 William married, and he and Dorothy were joined here by William's wife, Mary. *(G.P. Abraham, Ltd. Keswick)*

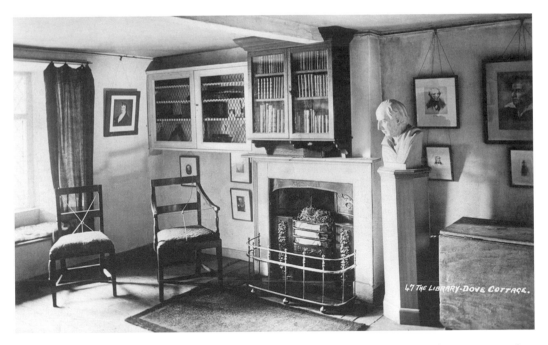

The library room in Dove Cottage, complete with a bust of the poet. Now a museum, the cottage was first opened to the public as early as 1917. *(Publisher unidentified)*

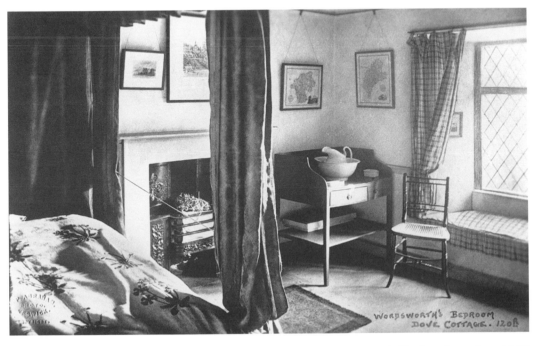

Wordsworth's bedroom at Dove Cottage. This view, like the preceding three, probably dates from about 1920 and shows how the rooms were furnished for display to visitors at that time. *(G.P. Abraham, Ltd. Keswick)*

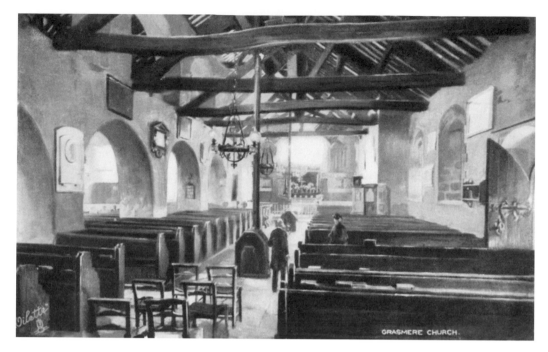

A postcard painting of the interior of St Oswald's Church, with its 'roof upheld / By naked rafters, intricately crossed.' (Book 5, *The Excursion*). On display here today are a memorial plaque to the poet (seen on the column on the left) and his personal prayer book. *(Raphael Tuck & Sons' "Oilette")*

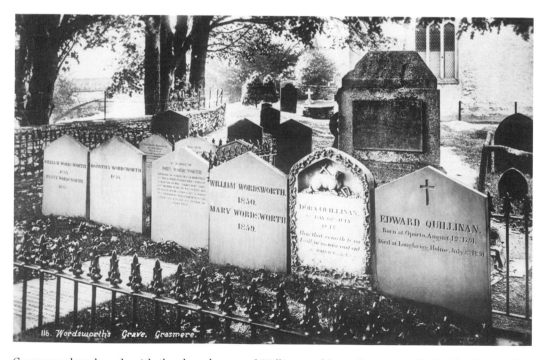

Grasmere churchyard, with the shared grave of William and his wife (centre) flanked by those of his daughter Dora and her husband Edward Quillinan, his sister Dorothy, and other family members. *(G.P. Abraham Ltd., Keswick)*

A selection of Wordsworthian quotations and pertinent images, dated 1916, cobbled together for sale to visitors to Grasmere as a not-very-attractive – but not untypical of the period – souvenir postcard. *(G.P. Abraham, Ltd. Keswick)*

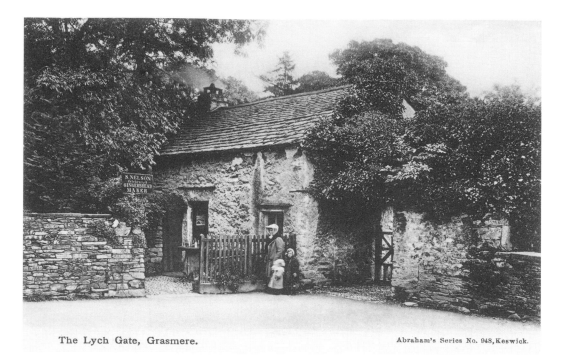

The Lych Gate, Grasmere. Abraham's Series No. 948, Keswick.

The lych gate on the north side of Grasmere churchyard, where traditionally coffins would be rested before being taken into the church. On the right is the former village school (from 1660 to 1854) where William's son John was educated (and he himself taught briefly in 1812). It is now a renowned gingerbread shop. *(Abraham's Series No. 948, Keswick)*

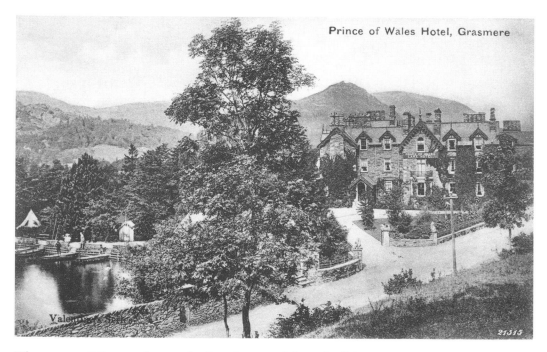

Prince of Wales Hotel, Grasmere

Where many of Grasmere's annual influx of visitors did – and still do – stay: the grand Prince of Wales Hotel on the Keswick Road. *(Valentine's Series)*

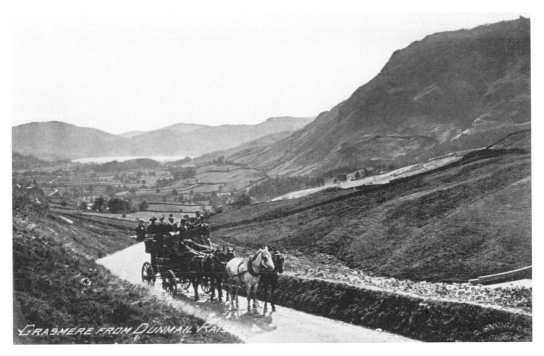

Following the Keswick road (now the A591) northwards out of Grasmere village, the watershed between the central and the northern lakes is reached at Dunmail Raise, reputedly the burial place of Dunmail, the last King of Cumberland, who died in battle in 945. *(The Art Publishing Company Glasgow)*

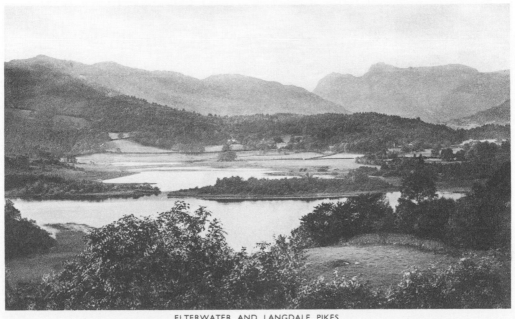

ELTERWATER AND LANGDALE PIKES

South of Grasmere, and high above it, lies the smallest of the lakes, Elterwater, just half a mile by a quarter in size; its name, from the Old Norse, means 'swan lake'. The view is westwards, to the peaks of Langdale Fell. *(G.P. Abraham, Ltd. Keswick)*

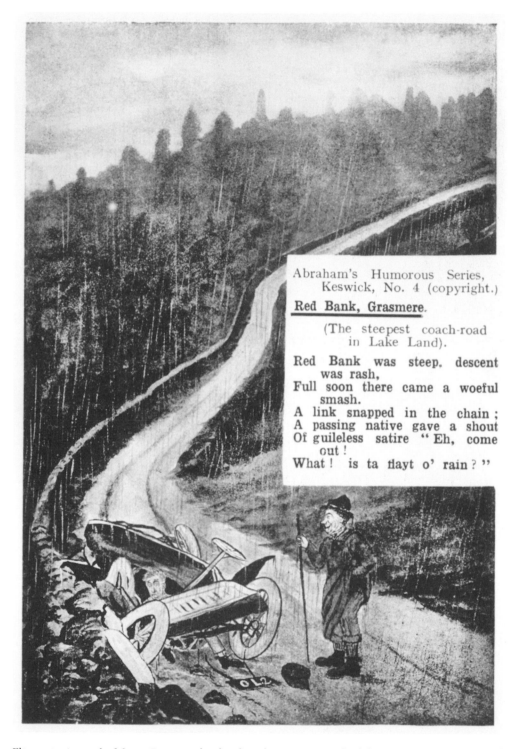

Elterwater is reached from Grasmere by the short but very steep climb known as Red Bank, which takes a minor road up beside Loughrigg Fell to Loughrigg Tarn and the lake. As often the case, such difficult climbs and passes have proved choice material for comic postcards down the years. (*Abraham's Humorous Series, Keswick, No. 4*)

On the north-western edge of Elterwater, at the entrance to Great Langdale, is Elterwater village and its youth hostel, an ideal base from which to explore the Lake District's most popular valley. *(Publisher unidentified)*

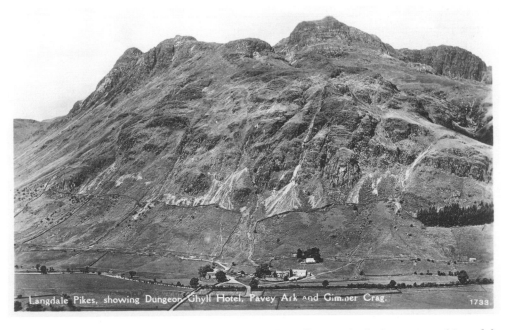

On the north side of Great Langdale, at the head of the valley, are the highest points of Langdale Fell, known collectively as the Langdale Pikes which, with their associated crags, tower above the valley's most famous hostelry, the Old Dungeon Gyhll Hotel. Known as the Middlefell Inn in the nineteenth century, it was donated to the National Trust early in the twentieth century by the historian G.M. Trevelyan. *(Atkinson & Pollitt, Kendal)*

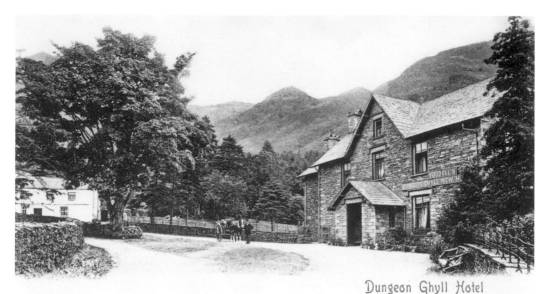

Dungeon Ghyll Hotel

Stengel & Co., London E. C. 39 Redcross Street 17207

The New Dungeon Ghyll Hotel, a mile or so down the valley, its youthful distinction aged by the passage of time. Both establishments take their name from the neighbouring 50ft-high Dungeon Ghyll Force waterfall hidden on the fell behind them, the setting for Wordsworth's 'The Idle Shepherd-Boys', an account of the heroic rescue of a drowning lamb. *(Stengel & Co., London E.C. 39 Redcross Street)*

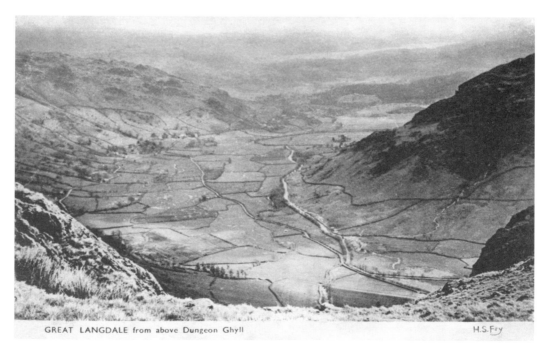

GREAT LANGDALE from above Dungeon Ghyll H.S.Fry

Looking eastwards back down the valley, its level floor occupied by its minor access road and the Great Langdale Beck. *(H.S. Fry)*

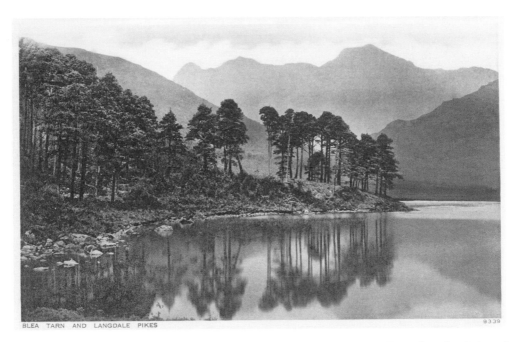

BLEA TARN AND LANGDALE PIKES 9339

High on the other side of Great Langdale, opposite the New Dungeon Ghyll Hotel, is the sheltered and very lovely Blea Tarn – one of three of that name in the Lake District – gained by following the minor road from the hotel up and out of the valley towards Little Langdale. *(No. 6 of a series of 48 pictures of Beautiful Britain issued with the "Greys" Cigarettes)*

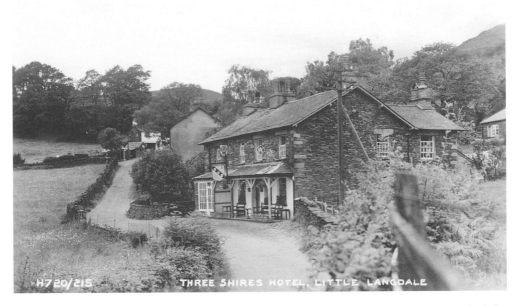

H720/215 THREE SHIRES HOTEL, LITTLE LANGDALE

The road from Blea Tarn drops south to the head of Little Langdale, at the eastern end of the Wrynose Pass. Halfway down the valley is the Three Shires Hotel, then as now another base for walkers exploring the area. Its name derives from the fact that the head of the valley was once the meeting point of Westmorland, Cumberland and that outlying part of Lancashire north of Morecambe Bay – now all in the modern county of Cumbria. *(Sankeys Ltd. Barrow-in-Furness)*

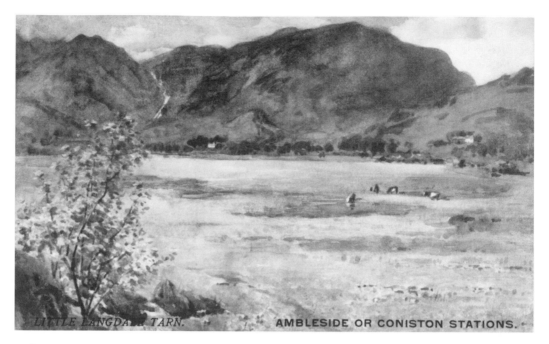

Little Langdale Tarn, just below the Three Shires Hotel. Note the curious untruth in the caption: while Coniston certainly possessed a railway station, Ambleside never did! *(Raphael Tuck & Sons, Ltd., for the Furness Railway)*

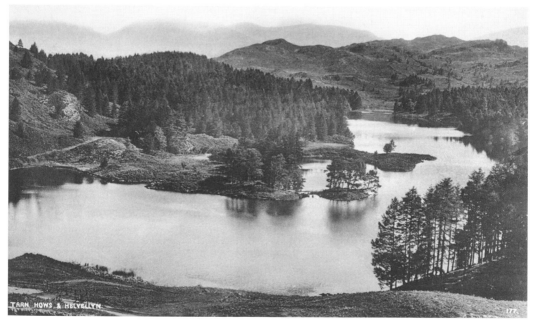

South of Little Langdale, and roughly midway between there, Esthwaite Water and Coniston Water, lies Tarn Haws, high in the Furness Fells and a long-time popular beauty spot. Formed from three small tarns in 1862 by a Yorkshire mill owner, who planted many trees around it, it was purchased in 1929 by Beatrix Potter who donated it to the National Trust the following year. It is now a Site of Special Scientific Interest. *(G.P. Abraham Ltd. Keswick)*

3

Coniston Water

'Mountains are the beginning and the end of all natural scenery.'

(John Ruskin, *Modern Painters*, 1856)

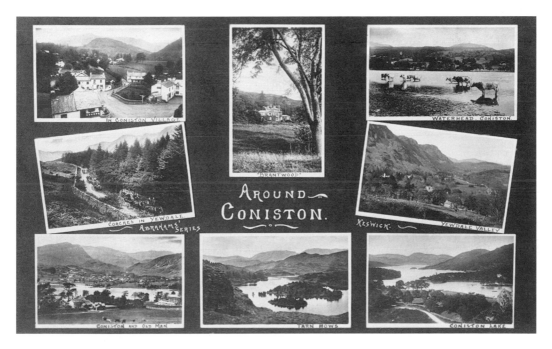

(G.P. Abraham, Ltd Keswick)

Immediately south of the two Langdales is the northern end of Coniston Water. This view is westwards across it to Coniston village and, towering above all else, the 2,635ft peak known as the Old Man of Coniston. *(Exclusive Grano Series The Photochrom Co. Ltd. London and Tunbridge Wells)*

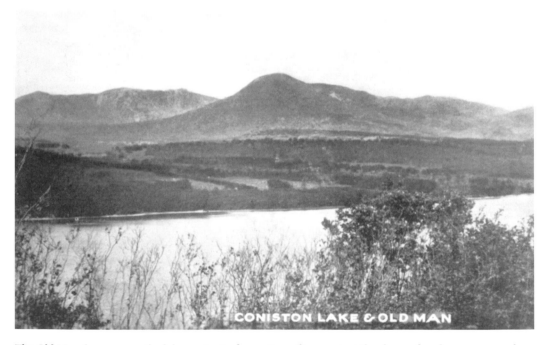

The Old Man from across the lake again, its dramatic outline against the sky rendered even more so by a slightly more southerly vantage point than that adopted in the previous card. *(The Unique Series)*

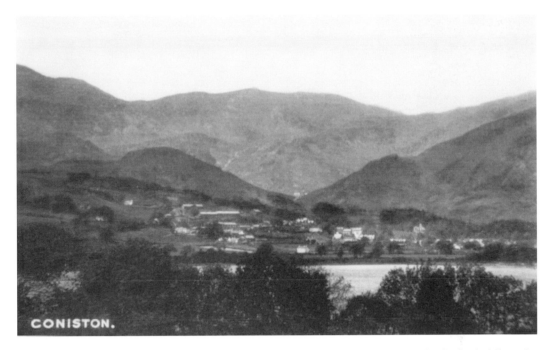

CONISTON.

The village from which Coniston Water takes its name, hemmed in on three sides by high fells – the Coniston Railway's branch line from the coast only managed to reach here from the south-west in 1859 by threading its way between the hills and the lake on comparatively level ground. *(The Unique Series)*

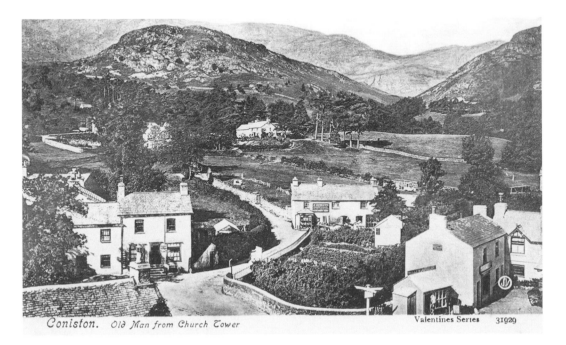

Coniston. Old Man from Church Tower Valentines Series 31929

The village of Coniston lies on the western shore just below the lake's northern extremity, where Yewdale Beck and Church Beck join its waters. Looking due west, the Old Man of Coniston is the mountain rising out of shot in the far left distance, beyond the rocky outcrop known as The Bell. *(Valentines Series)*

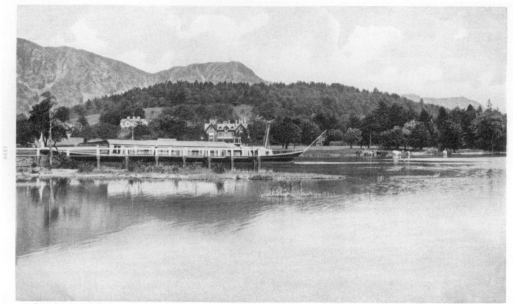

Coniston. Waterhead Hotel and Gondola.

The most famous boat on Coniston Water – and probably in the entire Lake District – is the steam yacht known as the *Gondola*. Built in 1859 by Jones Quiggan & Co. of Liverpool for the Coniston Railway (later the Furness Railway), she was a unique, sumptuously furnished pleasure craft. *(Peacock Brand "Autochrome" (Colour Photo) Postcard. Pictorial Stationery Co. Ltd., London)*

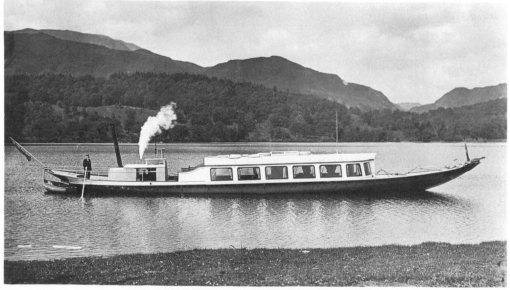

S.Y. "GONDOLA" ON CONISTON LAKE COPYRIGHT

The Coniston steamers ceased operations in 1939 at the outbreak of the Second World War and five years later the *Gondola* was sold to become a houseboat. After several years of dereliction, however, she was bought by the National Trust and totally rebuilt to inaugurate a new era of passenger services on the lake. *(Raphael Tuck & Sons, Ltd., for the Furness Railway "English Lakes Steamers" Series No. 9)*

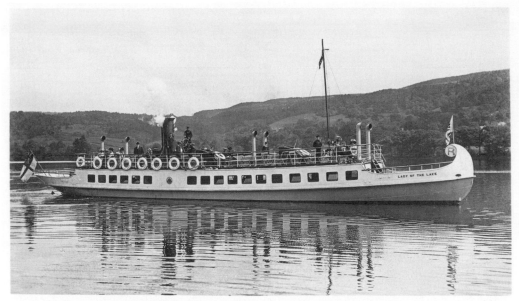

S.Y. "LADY OF THE LAKE" ON CONISTON LAKE

COPYRIGHT

The *Gondola* was joined, and largely replaced, in 1908 by the *Lady of the Lake*, a twin-screw steamer (captioned here as a steam yacht), supplied to the Furness Railway by the Southampton firm of Thornycroft. *(Raphael Tuck & Sons, Ltd., for the Furness Railway "English Lakes Steamers" Series No. 9)*

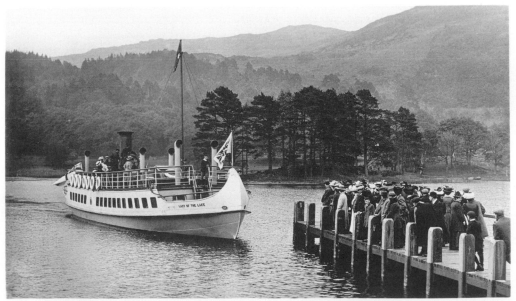

S.Y. "LADY OF THE LAKE" ARRIVING AT LAKE BANK PIER, CONISTON

COPYRIGHT

The *Lady of the Lake* arriving at Lake Bank, the steamer terminal at the southern tip of Coniston Water, probably just before the First World War. Like Windermere's *Tern* she sported a distinctive canoe stem, but like the *Gondola* she was withdrawn from service at the outbreak of the Second World War and was scrapped in 1950. *(Published unidentified)*

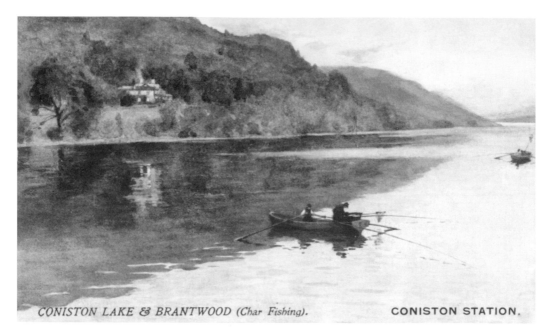

CONISTON LAKE & BRANTWOOD (Char Fishing). **CONISTON STATION.**

A mile or so south of the village of Coniston, on the opposite side of the lake, is Brantwood, the one-time home of the eminent writer and critic John Ruskin (1819–1900). The house, nestling beneath Crag Head, is seen on this 1907-franked official railway postcard beyond the char fishermen on the lake. *(Raphael Tuck & Sons, Ltd., for the Furness Railway. Series 2)*

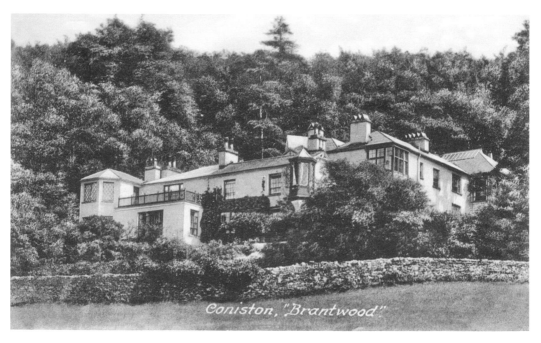

Coniston, "Brantwood"

Ruskin purchased Brantwood in 1871 for the sum of £1,500 and, after refurbishing it, lived there until his death. Today the house, a museum devoted to his life and art collection, is open to the public and can be reached either by the lake's eastern shore road or by the *Gondola* ferry service from Coniston. *(F. Frith, & Co., Ltd., Reigate)*

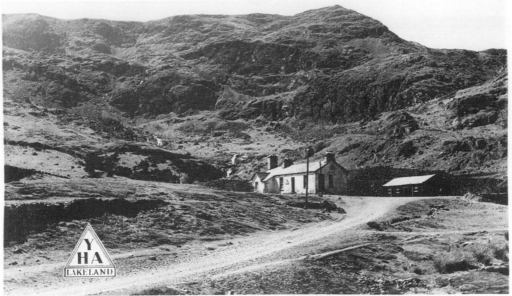

COPPERMINES HOUSE YOUTH HOSTEL, CONISTON.

Coppermines Youth Hostel, about a mile north-west of Coniston village and an ideal starting point from which to explore the Old Man and the surrounding fells. Its name commemorates the fact that these fells were once heavily mined for copper ore, the removal of which was the prime reason the railway branch was constructed. *(Photocrafts Ltd., Gateshead, Co. Durham)*

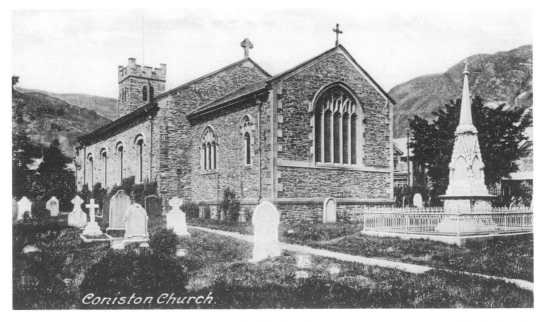

Coniston Church.

St Andrew's Church in Coniston, an 1819 rebuild of a 1586 structure. It was here, in 2001, that the body of Donald Campbell was finally laid to rest, thirty-four years after he was killed in the jet-powered *Bluebird* while attempting to break his own world water-speed record on the lake. This card was posted 31 December 1922 in Lancaster, sending the Carnforth recipient best wishes for the New Year. *(Frith's Series F. Frith & Co., Ltd., Reigate)*

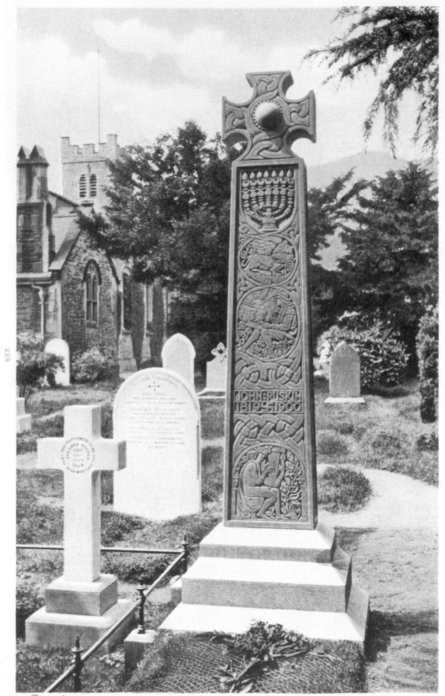

Coniston. The Ruskin Memorial.

In the churchyard at Coniston stands this Celtic cross memorial stone, marking John Ruskin's grave, carved from grey-green slate quarried at Tilberthwaite on the fells between Coniston and Little Langdale. *(Peacock "Autochrom" (Regd.) Post Card. The Pictorial Stationery Co., Ltd., London)*

4

Eskdale & Wastwater

'But how shall I speak of the deliciousness of the third prospect! At this time, that was most favoured by sunshine and shade. The green Vale of Esk – deep and green, with its glittering serpent stream, lay below us; and, on we looked to the Mountains near the Sea.'

(Dorothy Wordsworth, edited by William Wordsworth in *A Description of the Scenery of the Lakes in the North of England*, 1810)

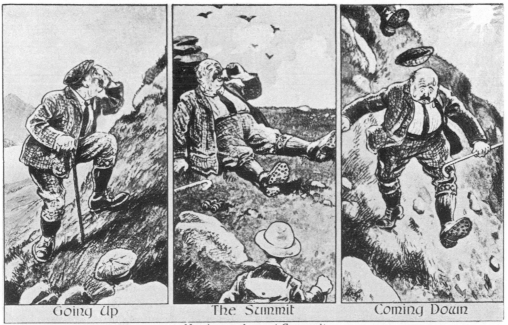

CLIMBING IN LAKELAND

Going Up The Summit Coming Down

Having a drop o' Summit

(Valentine's "Sepiatype" Series)

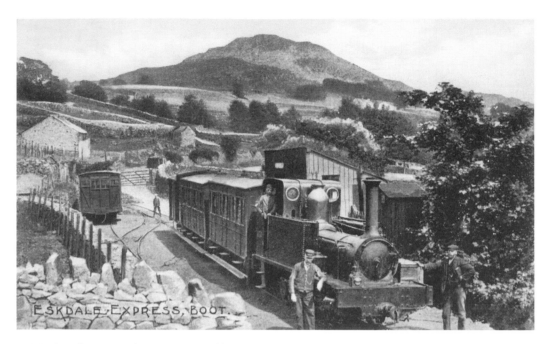

In 1875 a 3ft gauge railway was opened linking iron ore mines near Boot, at the head of Eskdale to the north-west of Coniston Water, with the Furness Railway at Ravenglass on the coast. The 'Eskdale Express' was this postcard publisher's tongue-in-cheek name for its slow-moving train. *(Moss's Series No. 186)*

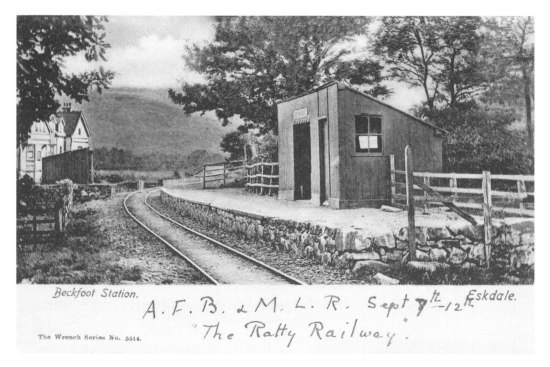

Beckfoot station, the first stop out from the Boot terminus. On the left is the Stanley Ghyll Hotel, built in the 1890s and another still in business today. *(The Wrench Series)*

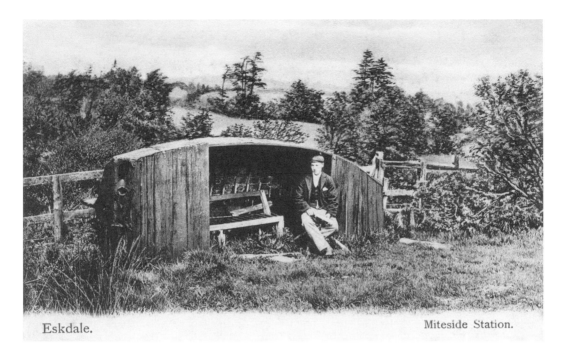

Eskdale. Miteside Station.

One of the less conventional stations on the Ratty – as the Ravenglass & Eskdale Railway was known locally – was this halt, close to the River Mite, just 1½ miles out from Ravenglass. The bow half of an upturned boat forms today's shelter. *(The Wrench Series No. 5506)*

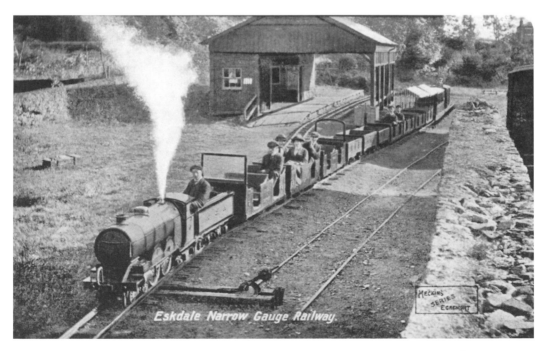

Eskdale Narrow Gauge Railway.

In 1913 the Ratty closed, after many years of financial hardship, but was reborn two years later as a 15in gauge miniature railway – and a major tourist attraction today. This is the 'new' Ravenglass station – note the old 3ft gauge track on the right. *(Meckin's Copyright Series, Egremont)*

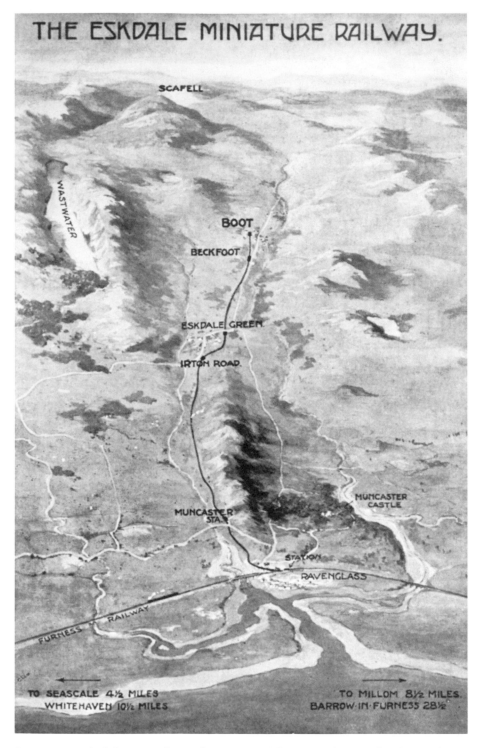

A map postcard of the new railway – known as 'La'al Ratty' to distinguish it from its bigger predecessor – with the principal stations marked. The orientation is north-eastwards, towards the centre of the Lake District, with Wastwater on the left and the smaller Devoke Water tarn on the right. *(The Locomotive Publishing Co., Ltd., 3, Amen Corner, London, E.C.)*

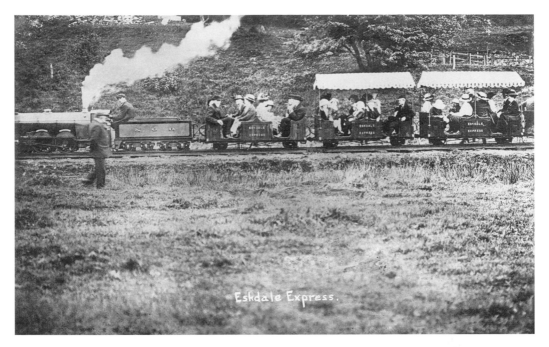

Another very early view of the new 'Eskdale Express', the carriages now proudly carrying that name! The engine (as on page 67) is *Sans Pareil*, a product of the Northampton model-making firm of Bassett-Lowke. It is lettered N.G.R. on the tender, Narrow Gauge Railways Ltd being the new operating company. (*Publisher unidentified*)

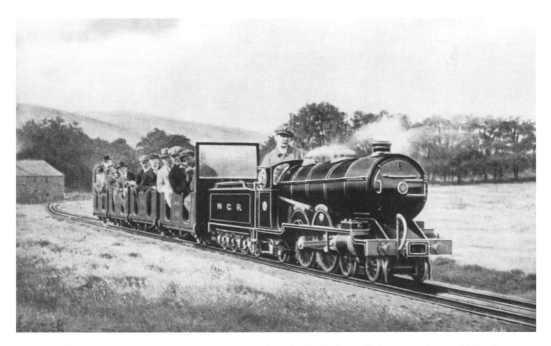

Sans Pareil again, this time on a colour-enhanced card which showed the engine's royal blue livery to great effect. (*The Locomotive Publishing Co., Ltd., 3, Amen Corner, London, E.C.*)

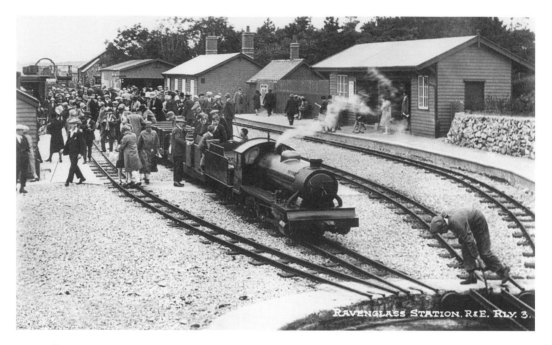

Ravenglass station, on a 1949-franked card. The sender has written: 'Having a grand time. Have been on this train today – it's lovely am writing this sitting in the small trucks.' *(Publisher unidentified)*

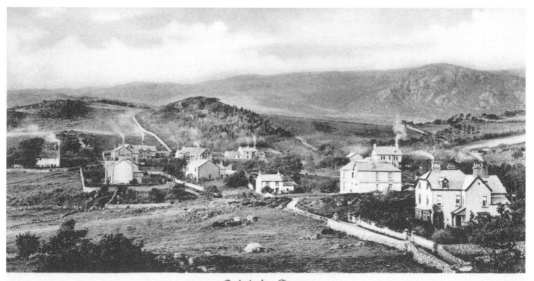

The only sizeable village on the R&ER is Eskdale Green, halfway up the line. This scene is recognisable today, though much in-filling with houses has occurred since this pre-First World War photograph was taken. *(The Wrench Series)*

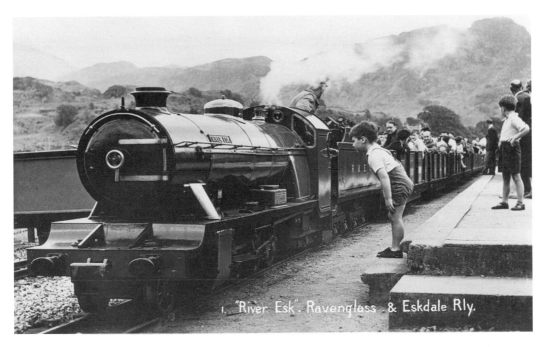

The abiding fascination of steam engines for small – and large – boys the world over: Dalegarth station by Boot, the railway's upper terminus opened, in 1922, on level ground to replace the short, stiff climb to the old station. The locomotive is *River Esk*, built in 1923 by the Colchester firm of Davey, Paxman & Co. Ltd. *(Publisher unidentified)*

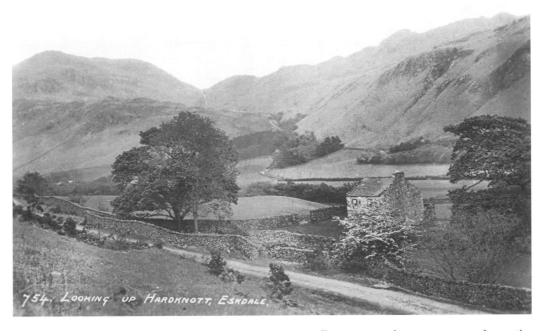

At the head of Eskdale is the notorious – for motorists – Hardknott Pass, taking a minor road over the watershed into the central region of the Lake District: the short way to cross the fells from west to east but certainly not one for the timid driver! *(Pettitt's Prize Medal Series, Keswick)*

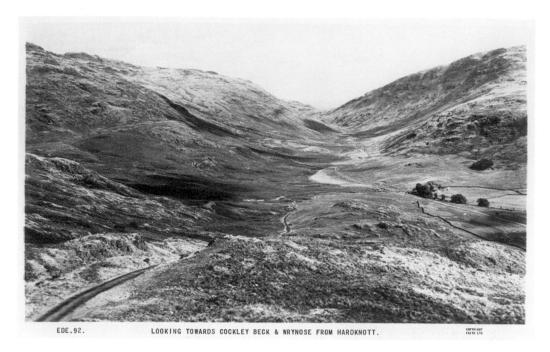

EDE.92. LOOKING TOWARDS COCKLEY BECK & WRYNOSE FROM HARDKNOTT. COPYRIGHT FRITH LTD

The eastern end of the Hardknott Pass where its continuation, the Wrynose Pass, takes the road into Little Langdale. *(F. Frith & Co. Ltd., Reigate)*

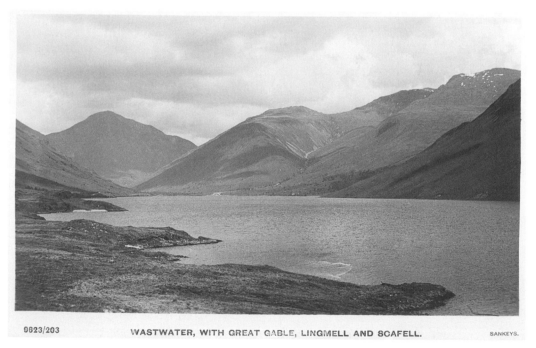

9623/203 WASTWATER, WITH GREAT GABLE, LINGMELL AND SCAFELL. SANKEYS.

Immediately north of Dalegarth, over the Eskdale Fells, lies Wastwater, the most dramatic – or most dismal, depending on the weather – of all the lakes. This view is towards the head of the lake and its lofty companions. *(Sankeys)*

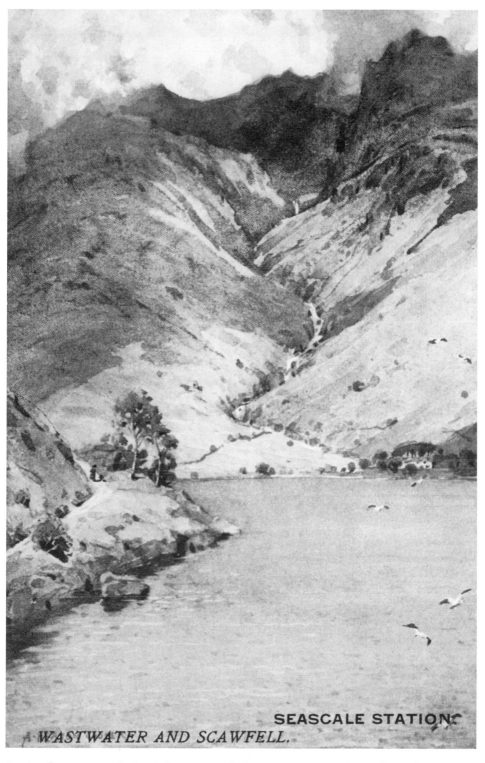

A painted view across the head of Wastwater, looking towards Sca Fell top right, with the silvery waters of Lingmell Gill cutting their way down to the lake by Wasdalehead Farm. *(Raphael Tuck & Sons, Ltd., for the Furness Railway)*

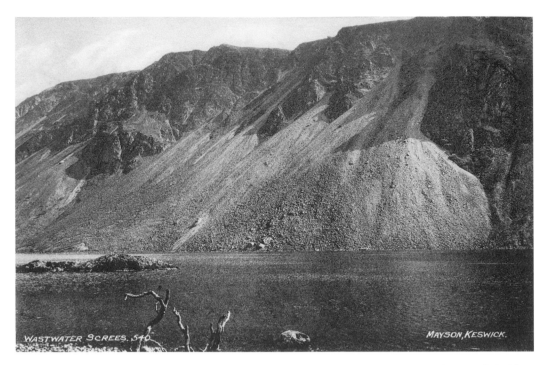

With a maximum depth of 258ft, Wastwater is by far the deepest of the lakes and, with steep, forbidding crags – and their famous screes – on its southern side, is largely shielded from the direct rays of the sun for much of the time, hence its gloomy reputation. *(H. Mayson's Series)*

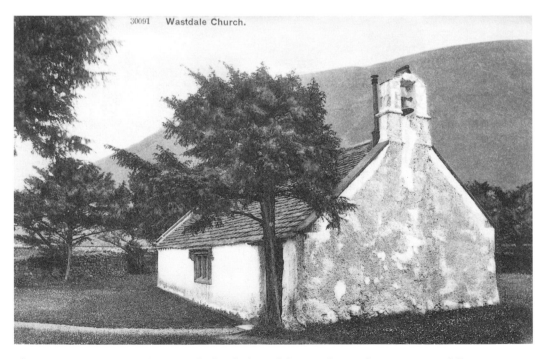

The seventeenth-century church at the head of Wasdale, one of several purporting, at different times, to be the smallest such building in England. *(Photochrom Co., Ltd., London and Detroit, U.S.A.)*

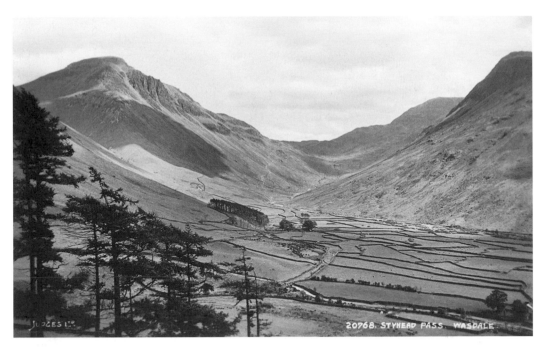

Beyond Wasdale Head lies Styhead Pass (or simply The Sty, meaning 'ladder'), a roadless pass between Great Gable and Sca Fell leading to Borrowdale and Great Langdale. *(Judges' Ltd., Hastings)*

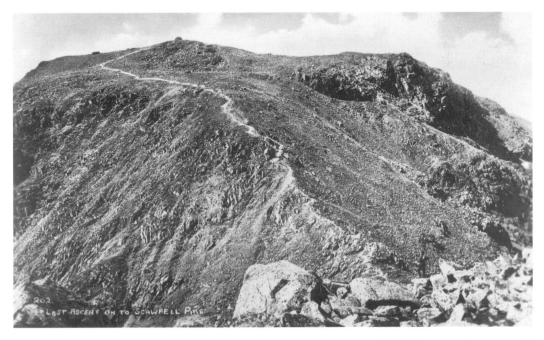

Rising to the east of Wasdale Head is Sca Fell with its highest peak, Scafell Pike, being, at about 3,210ft above sea level, England's highest point. *(Publisher unidentified)*

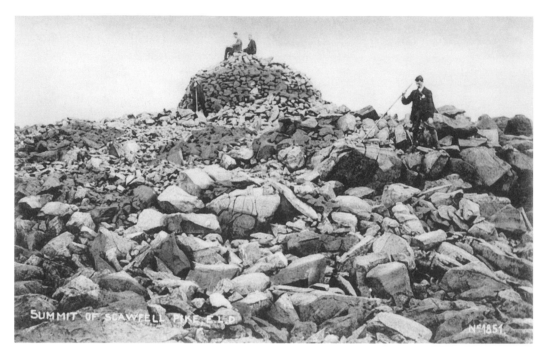

On the summit of Scafell Pike (note the variant spelling of the period) with a group of young Edwardian gentlemen posing nonchalantly for the camera. *(The "Phoenix" Series Brittain & Wright, Stockton-on-Tees)*

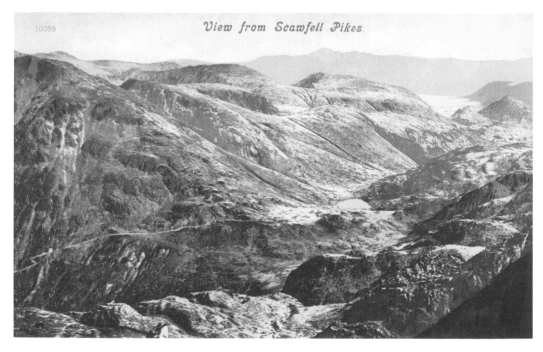

Looking northwards from the Sca Fell massif – 'pikes' here meaning 'peaks' – down Borrowdale past Great Gable (left) and Sty Head Tarn (centre) to Derwent Water. *(Publisher unidentified)*

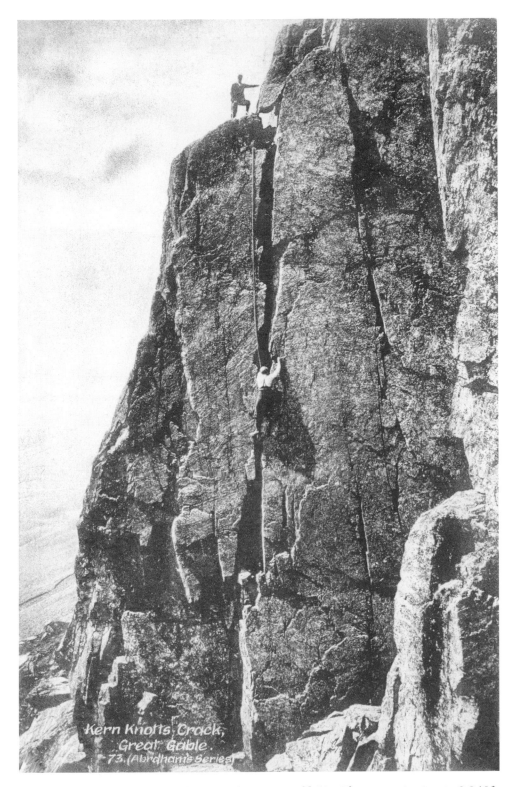

Climbers on Great Gable, probably before the First World War. The mountain rises to 2,949ft above sea level. *(Abraham's Series)*

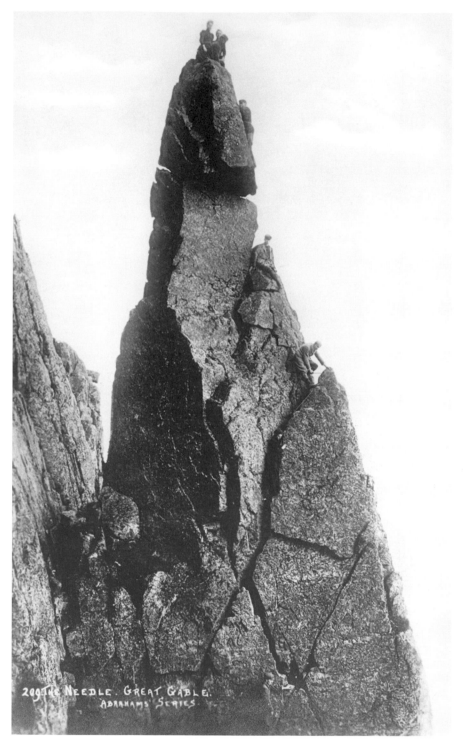

Another of Great Gable's rocky pinnacles so beloved of climbers, the aptly named Needle, probably in the 1920s. Rather astonishingly, as regards both the conventions of the time and the difficulty of the ascent, the group at the very top includes a woman in a full-length dress! *(G.P. Abraham, Ltd Keswick)*

5

The North-Western Lakes

When, having left his Mountains, to the Towers
Of Cockermouth that beauteous River came,
Behind my Father's House he passed close by,
Along the margin of our Terrace Walk.

(William Wordsworth, 'The Prelude', Book 1)

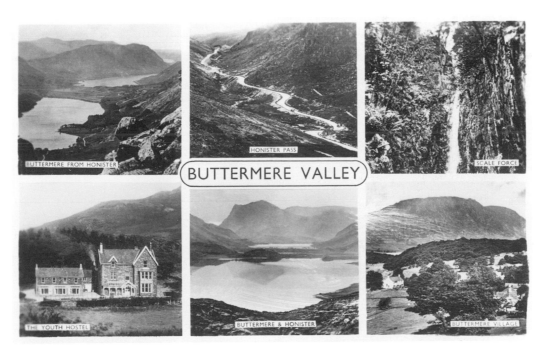

(G.P. Abraham Ltd., Keswick)

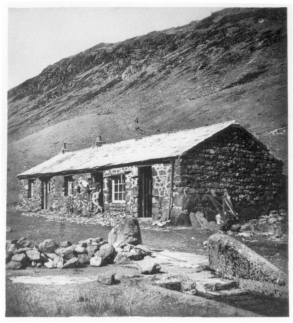

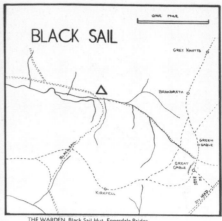

THE WARDEN, Black Sail Hut, Ennerdale Bridge, Cleator, Cumberland. Notice must be given Warden well in advance. Replies by return post impossible.

POSITION AND MAP. Head of Ennerdale, under Haystacks turn left from foot of Scarf Gap Pass. or left from foot of Black Sail Pass, or fo.low Bec' down from Wind Gap, if approaching from Sty Head. O.S. Lak District Tourist, 82. G.k. 194124. Bart. 34.

HOSTEL DETAILS. M 10. W 8. Open Easter—Oct. 31st. P.O.: Rosthwaite 6 m. R. bathing No. S.B.H.

NEXT HOSTELS. Borrowdale 7-10 m. Nether Wasdale 8 m. Eskett 11 m. Honister 3 m (over mountain). Gillerthwaite 4 m.

Continuing our clockwise tour of the Lake District, the next major body of water encountered north of Wastwater is Ennerdale Water. Black Sail Youth Hostel, a former shepherd's hut, is high up the valley by the River Liza, in the shadow of Great Gable – and only accessible on foot. (*Geo. W. Logan & Co., Consett, Co. Durham*)

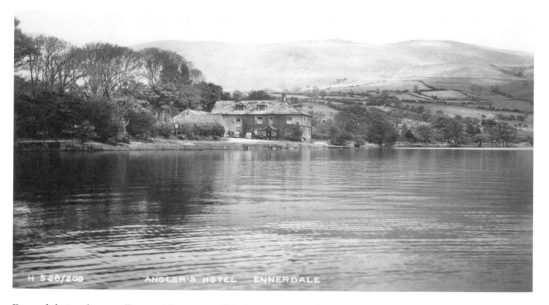

Ennerdale is a long valley, and less accessible for motorists than Wasdale – a fact that no doubt pleases Wordsworth's spirit! Its lake, Ennerdale Water, occupies its lower half and is fed by the River Liza from the east and drained by the River Eden at its western end. Sadly, the popular Angler's Hotel was demolished in 1960 in readiness for turning the lake into a reservoir, though two decades of public opposition killed the idea; its site is marked by a bench dedicated to the inn's former owners. (*Sankeys, Barrow*)

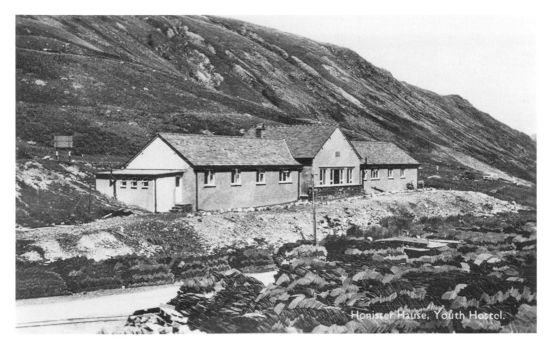

To the north-east of Ennerdale, three lakes – Buttermere, Crummock Water and Loweswater – are strung together down a long valley system, known as the Vale of Lorton. Headed by the awesome Honister Pass (connecting with Borrowdale to the east), it comes complete with a youth hostel at the 1,167ft summit. *(Publisher unidentified)*

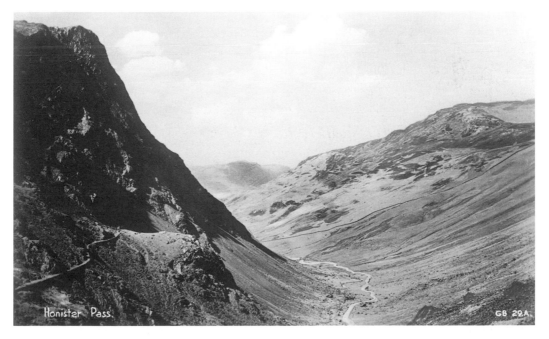

Honister Pass in all its magnificent glory, looking down on the B5289. The pass is home to the last working slate mine in England (now open to the public), a survivor of a once-extensive industry supplying roofing and other building materials to the region over many centuries. *(H. Webster Helvellyn House, Keswick)*

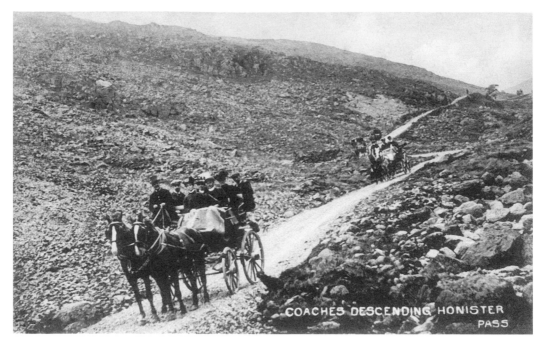

Coaches descending the Honister Pass before the First World War. Such views of British mountain passes were a popular subject with postcard publishers, who would usually exaggerate the gradient depicted for dramatic effect! *(H. Mayson's Series)*

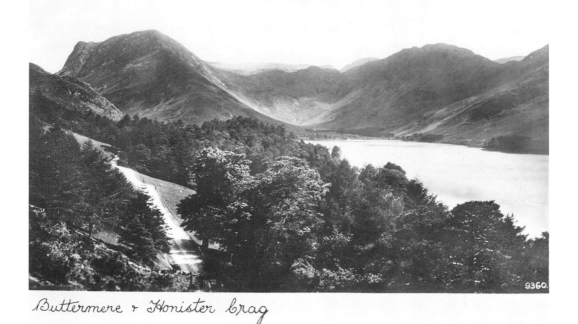

Looking towards the head of Buttermere, with the wooded lower slopes of Buttermere Fell on the left, immediately beyond which is the entrance to the Honister Pass. *(The Photochrom Co. Ltd. Graphic Works Tunbridge Wells)*

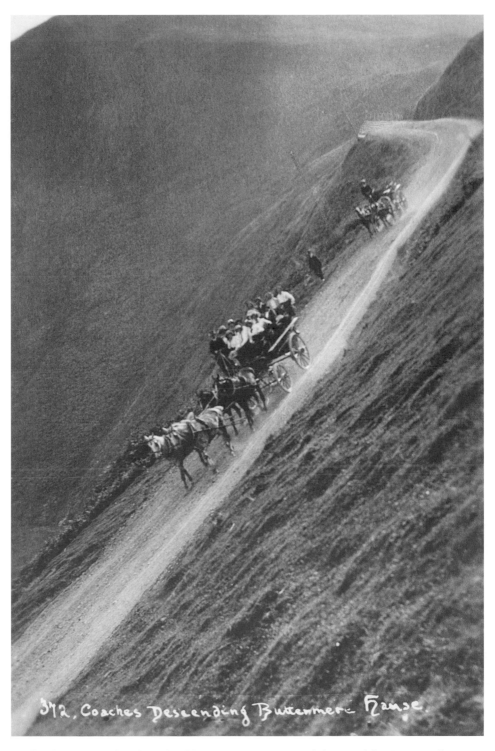

372. Coaches Descending Buttermere Hause.

On the short strip of low-lying land between Buttermere and the next lake, Crummock Water, is the village of Buttermere, reached on the north-eastern side by this steep drop (also known as Newlands Pass) off the Derwent Fells. This time the road's gradient has been implausibly exaggerated by the publisher! *(Pettitt Keswick)*

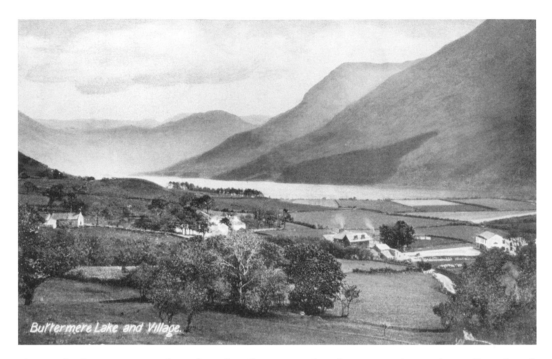

The view back up Buttermere from above the village on an Edwardian postcard. Note the small patchwork of meadows and fields, squashed in between fells and lakes, which gave rise to Buttermere's name: 'the lake by the pastures'. *(J.W.B. London, E.)*

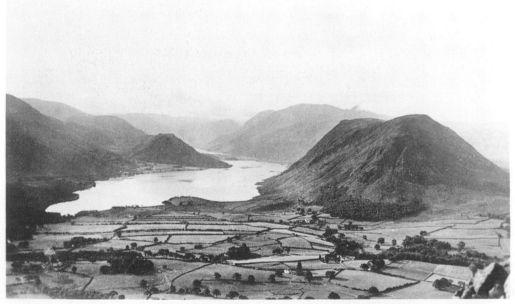

To the north of Buttermere is the charming Crummock Water. Larger than Buttermere, it is drained at its northern end – in the foreground – by the River Cocker. Mellbreak is the impressive, volcano-shaped peak to the right. *(M and L National Series)*

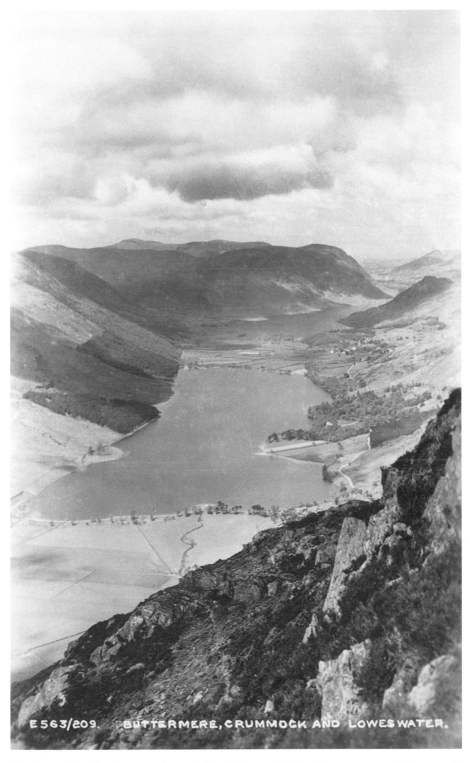

E 563/209. BUTTERMERE, CRUMMOCK AND LOWESWATER.

The three lakes, looking northwards from Fleetwood Pike: Buttermere and Crummock Water – probably one lake in the geological past – with a glimpse of Loweswater in the far distance. *(Publisher unidentified)*

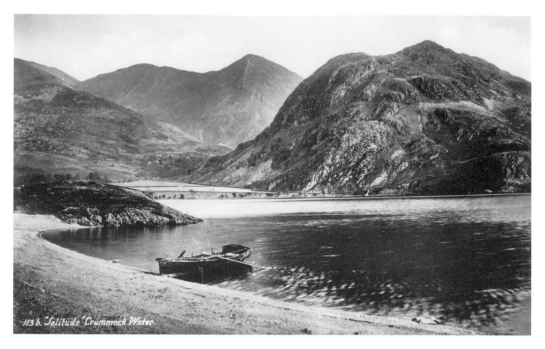

Crummock Water, some 2½ miles in length. Its name is thought to derive from a Celtic word for 'crooked', referring to its bent shape. Note the boat in the foreground – a common publishers' pictorial device to give a sense of scale and human interest to the scene. *(G.P. Abraham, Ltd., Keswick)*

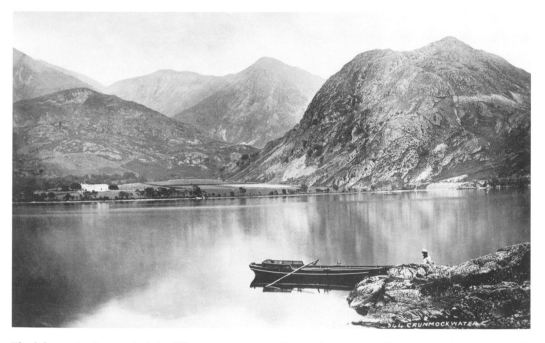

The lake again, from a slightly different perspective. The sender, in 1906, has written that 'Crummock Water, on whose banks I played with the pebbles one hot August afternoon, struck me as being one of the most restful places I had ever seen. It was a wonderful blend of solitude, grandeur, and loveliness. It was with difficulty I tore myself away.' *(Publisher unidentified)*

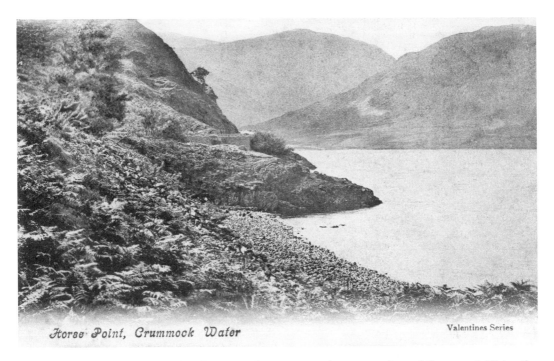

Horse Point, Crummock Water

Valentines Series

Hawse Point – incorrectly spelled in the postcard caption – on the eastern shore of Crummock Water, the point at which the lake 'kinks'. *(Valentines Series)*

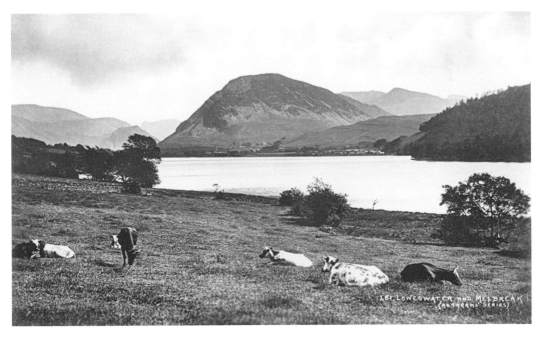

Feeding its waters into Crummock Water, via the Dub Beck then the Park Beck from the north-west, is the outlying Loweswater – the only lake that drains *towards* the centre of the Lake District. To the south-east can be seen the distinctive shape of Mellbreak again. *(G.P. Abraham Ltd, Keswick)*

Looking across the southern end of Loweswater towards the 1,676ft-high Mellbreak. The sender, in 1943, has written: 'We scrambled up the hill in the background on Sunday evening & had a good view of Loweswater, Crummock & Buttermere lakes. We could also see Solway Firth in the distance. It was grand' – and no doubt a welcome respite from the war then raging. *(Raphael Tuck & Sons, Ltd)*

Although the town of Cockermouth, to the north of the three lakes, lies outside the National Park, this postcard is included here as it depicts the house, in Main Street, where William Wordsworth was born on 7 April 1770, the second of a lawyer's five children. This was where he lived and played until sent to school in Hawkshead (see page 36), and is now another National Trust property open to the public. *("Sankey" High-Speed Machine Real Photo)*

6

Keswick & the Northern Lakes

Sweet are the sounds that mingle from afar,
Heard by calm lakes, as peeps the folding star,
Where the duck dabbles 'mid the rustling sedge,
And feeding pike starts from the water's edge,
Or the swan stirs the reeds, his neck and bill
Wetting, that dip upon the water still;
And heron, as resounds the trodden shore,
Shoots upward, darting his long neck before.

(William Wordsworth, 'An Evening Walk')

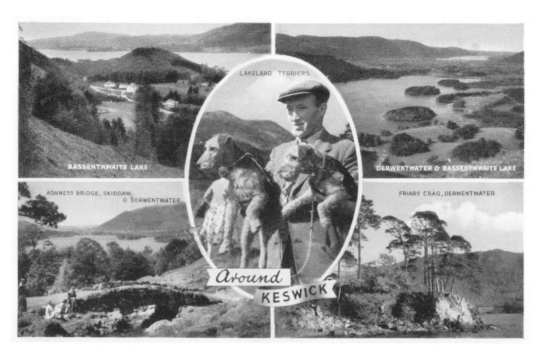

(E.T.W. Dennis & Sons, Ltd., London and Scarborough)

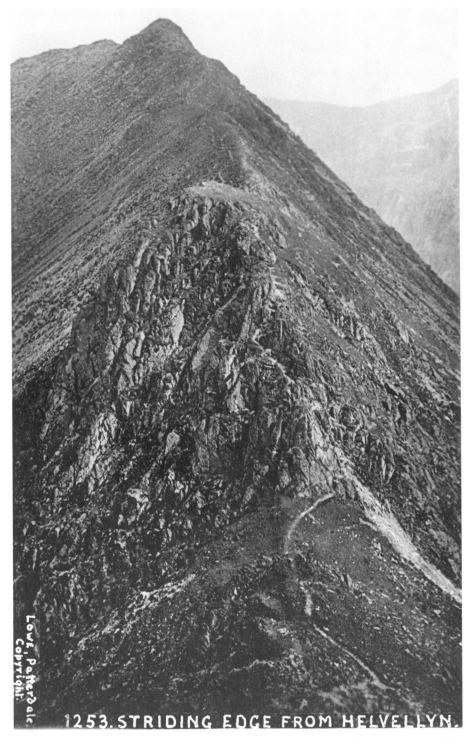

1253. STRIDING EDGE FROM HELVELLYN.

North of the central lakes is the long, narrow Thirlmere, overlooked on its eastern side by the 3,118ft peak of Helvellyn. Helvellyn is considered one of the best mountains to climb in the Lake District – but is not that hard by some routes, for Wordsworth managed the ascent at the age of seventy! *(Lowe, Patterdale)*

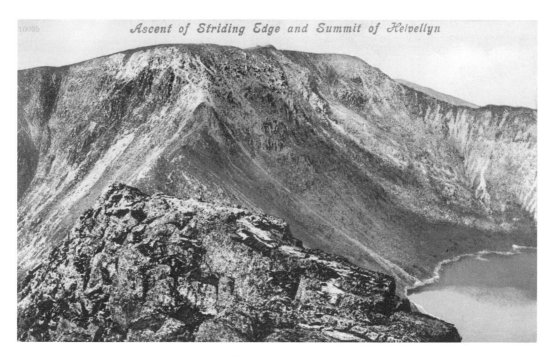

One of the most dramatic ascents of Helvellyn is from its east, via the narrow ridge known as Striding Edge. Lower right is Red Tarn, so called because its water can appear dark red at sunrise. (*Publisher unidentified*)

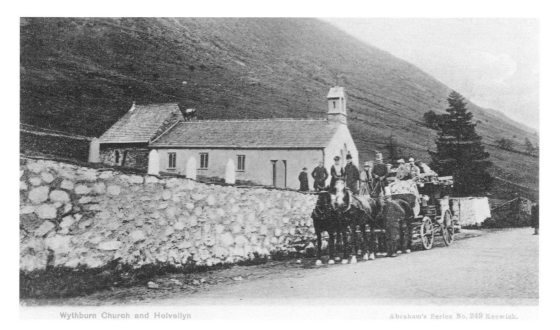

At the southern tip of Thirlmere, on the main A591 road from Ambleside along its eastern shore, is the village of Wythburn – or what is left of it for in the 1890s two small lakes, Leatheswater and Brackmere, were transformed into a reservoir by Manchester Corporation, drowning the village of Wythburn in the process. The church, which dates from 1640, is one of the few surviving buildings. (*Abraham's Series No. 249 Keswick*)

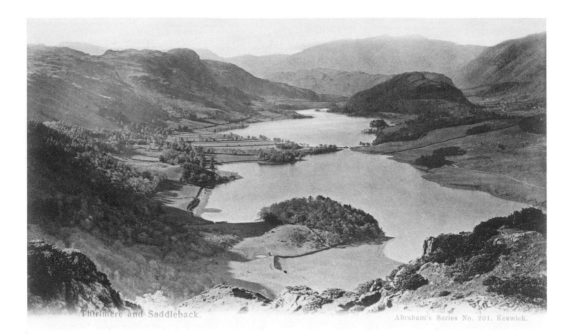

The whole of Thirlmere, looking north towards the distinctive 2,848ft-high mass of Saddleback – or Blencathra – in the distance. With the water level low, the two-lake origin of the reservoir is readily apparent. *(Abraham's Series No. 201. Keswick)*

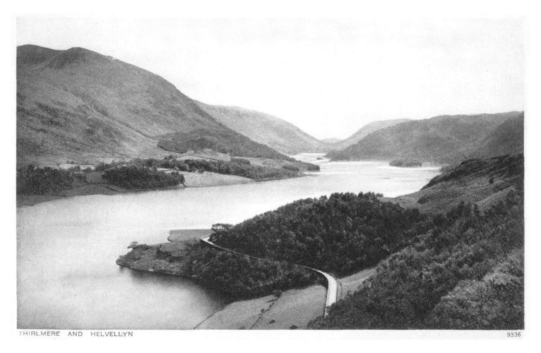

The view in the opposite direction, looking up to the southern head of the reservoir – rather fuller than on the previous card – with the bulk of Helvellyn looming large on the left. *(Photochrom Co. Ltd., London and Tunbridge Wells)*

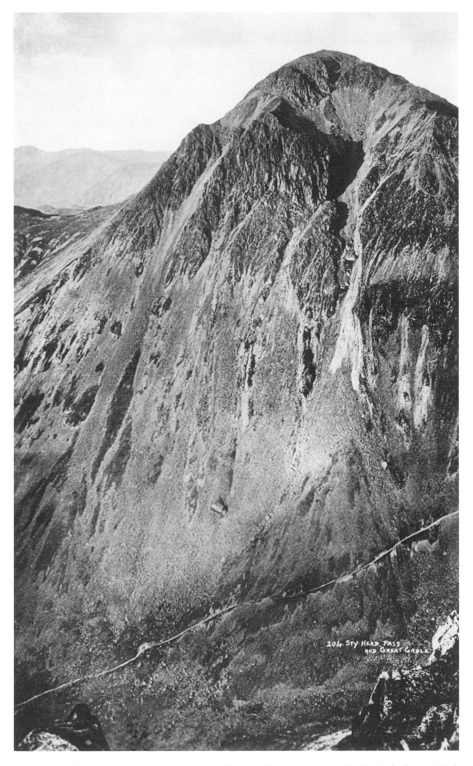

West of Thirlmere is the valley of Borrowdale, at the extreme head of which the 2,949ft peak of Great Gable towers over the Sty Head Pass (see page 75) linking Borrowdale to Wasdale. *(G.P. Abraham, Ltd., Keswick)*

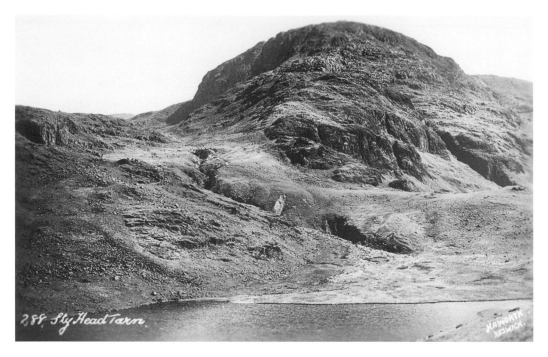

In the shadow of Great Gable is Styhead Tarn (see page 76), which feeds its water, via Styhead Gill, down into Borrowdale. *(Haworth, Keswick)*

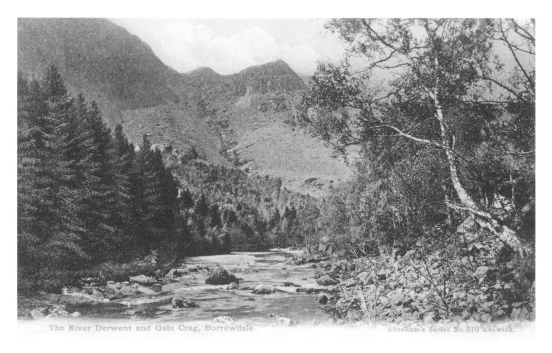

The head of Borrowdale is divided into two parts, like an inverted letter Y, with the Sty Head waters flowing in from the south-west, and the young River Derwent in from the south-east. *(Abraham's Series No. 610 Keswick)*

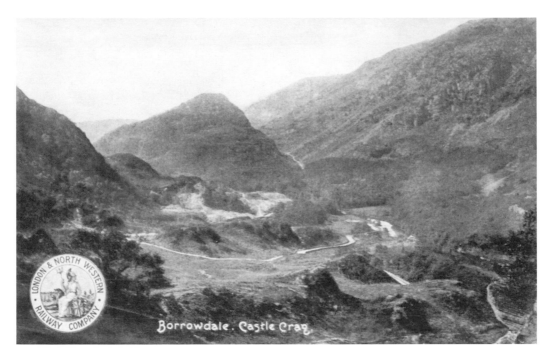

The spot where Borrowdale divides, split by the rocky outcrop of Castle Crag, with the River Derwent coming in from the left. *(McCorquodale & Co., Ltd)*

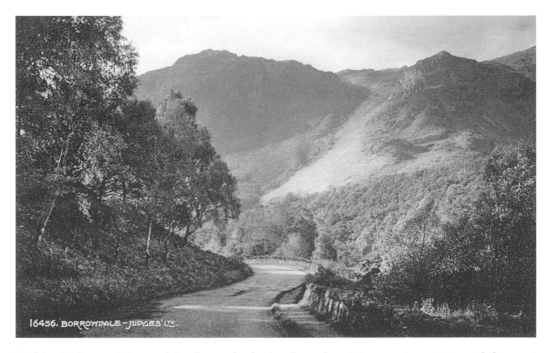

Within the heart of Borrowdale, the road a lot less busy than it is now at most times of the year! *(Judges' Ltd., Hastings)*

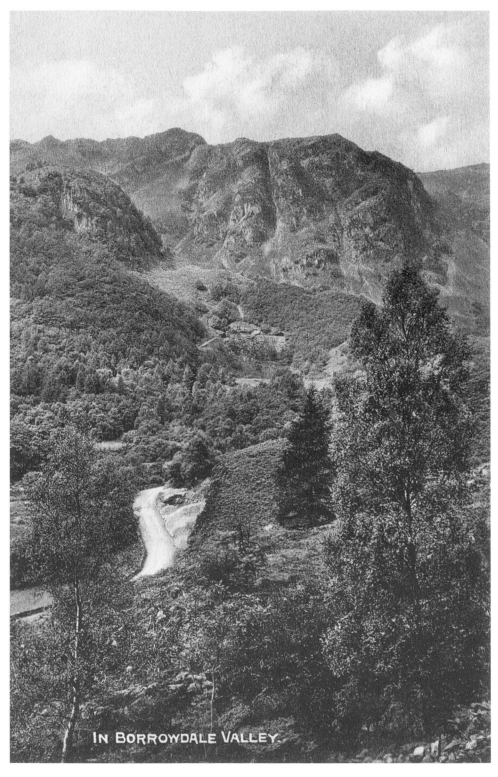

IN BORROWDALE VALLEY.

Another view of the valley, this time with the postcard's portrait format doing full justice to Borrowdale's stunning mix of woods and crags. *(H. Mayson's Series)*

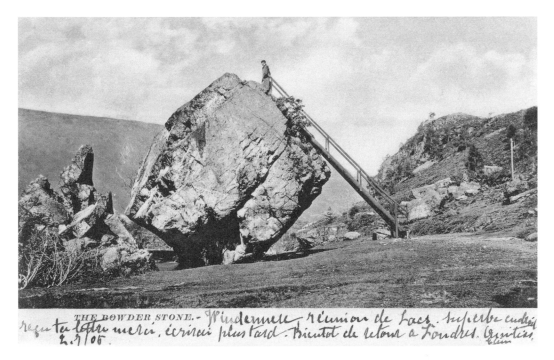

THE BOWDER STONE. - *Windermere - réunion de Lacs. superbe endroit - regu ta lettre merci, écrirai plus tard. Bientôt de retour à Londres. amitiés. Elim. 2.7/06.*

One of the most striking geological features of the Lake District is Borrowdale's Bowder Stone, a 1,970-ton boulder standing in splendid isolation beside the main road less than a mile south of the hamlet of Grange. *(Publisher unidentified)*

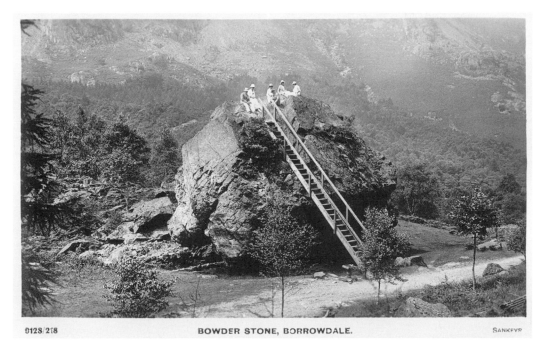

8128/218 BOWDER STONE, BORROWDALE. SANKEYS

The Bowder Stone from the side. The massive rock measures approximately 62ft across at its widest and, with a height of 36ft, makes an ideal vantage point from which to survey this part of the valley. *(Sankeys Photo Press, Barrow-in-Furness)*

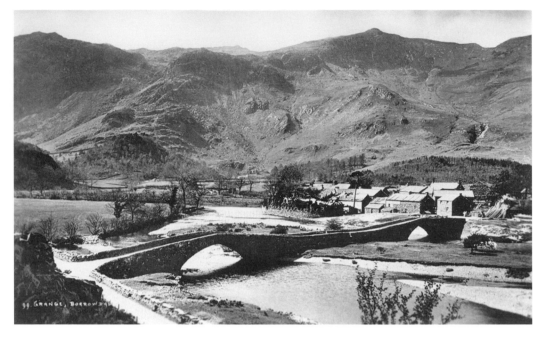

The pretty hamlet of Grange – officially Grange-in-Borrowdale – halfway between the Bowder Stone and Derwent Water, with the bridge over the Derwent to the fore . . . *(G.P. Abraham, Ltd. Keswick*

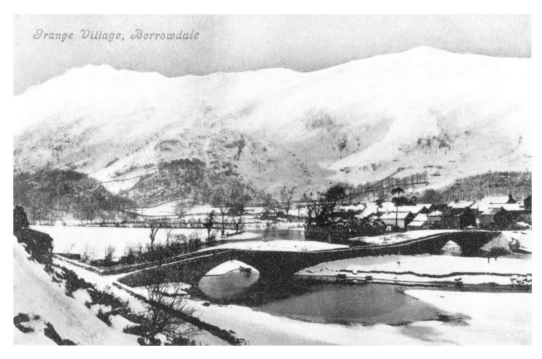

. . . and the same view in the depths of winter – another type of image beloved of postcard publishers in their efforts to sell cards throughout the year. The ploy obviously worked in this case for the sender has written: 'The lake mountains are just like this at present.' *(Valentine's Series)*

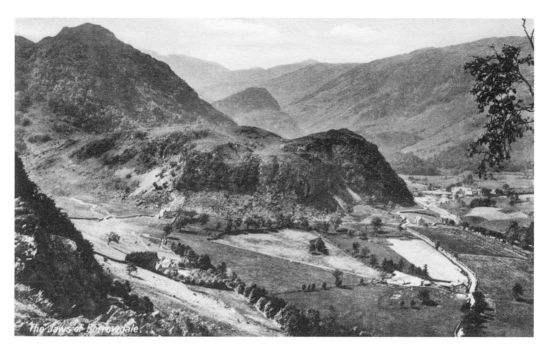

Below Grange, Borrowdale opens out markedly. This view, back to the hamlet (far right), shows the famous 'Jaws of Borrowdale', constricting Grange and the valley beyond. *(Publisher unidentified)*

East of Grange and the Bowder Stone, high on the Watendlath Fell, is the hamlet of that name and its tarn – another source of supply to Derwent Water. *(G.P. Abraham, Ltd. Keswick)*

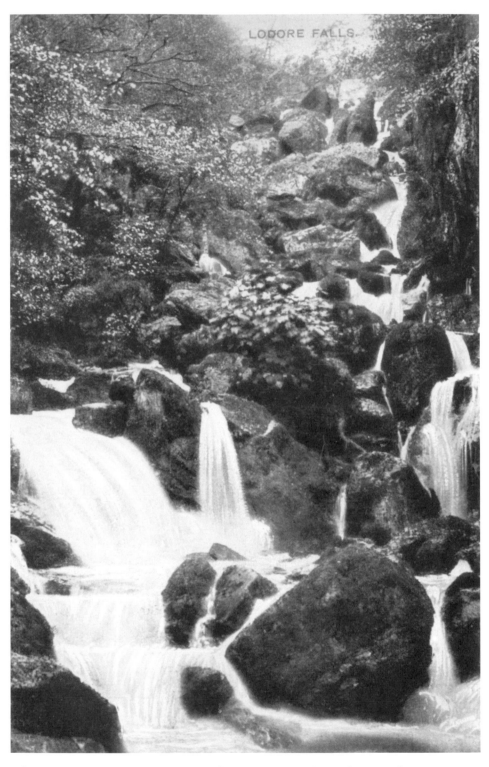

Below Grange, a flat plain takes the meandering Derwent to the southern tip of Derwent Water. Tumbling down from the south-east to join the lake nearby is Watendlath Beck, with its 40ft cataract known as the Ladore Falls. *(The Star Series – G.D. & D., – London)*

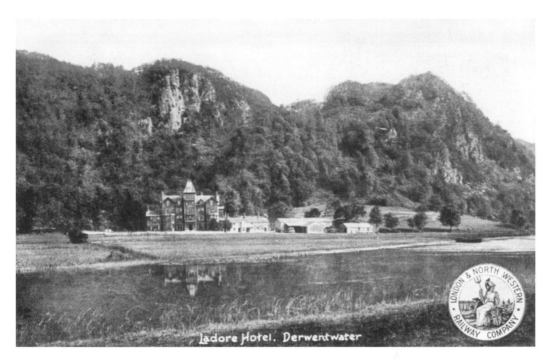

Ladore Falls are owned by the Ladore Hotel, situated at the south-east corner of Derwent Water, where the River Derwent joins it. The hotel is captured here on another LNWR official postcard. *(Mccorquodale & Co., Ltd)*

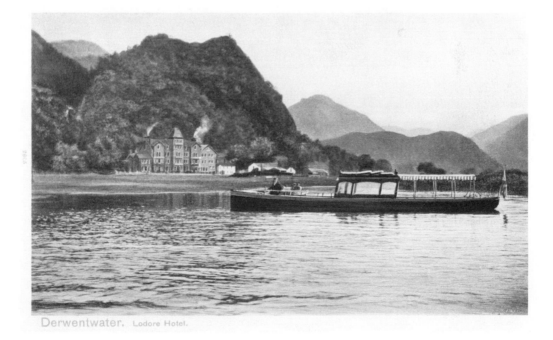

The hotel again, its beautiful setting serving as a backdrop to an elegant but unidentified motor launch. *(Peacock "Autochrom" Post Card. The Pictorial Stationery Co., Ltd., London)*

KESWICK.

Keswick Hotel,

DERWENTWATER, KESWICK.

Stands in its own Grounds of several acres, adjoining the Station.

Telegraph and Telephone Offices on the premises.

PASSENGER ELEVATOR.

LIGHTED BY ELECTRICITY.

GOLF.

E. WILSON, Proprietor.

THE LODORE HOTEL,

DERWENTWATER, KESWICK.

"How does the water come down at Lodore?"—*Southey.*

PATRONIZED by their Royal Highnesses the Prince of Wales and the **Duke of Connaught.** This First-class Family Hotel, standing in its own pleasure grounds at the Head of the Lake near the celebrated Falls of Lodore, commands the view of the whole of Derwentwater, its romantic islands and majestic mountains, in the heart of all the most beautiful scenery, lovely walks and drives. Excellent Cycling and Boating. It has been entirely refurnished and remodelled, also the Lavatories and Sanitary arrangements entirely renovated. Tariff Moderate. Boarding Terms. Omnibus meets all Trains, also Coaches from Windermere and Ambleside. Posting, Fishing, Steam Yacht.

Post and Telegraph Office in Hotel. MRS. EDWARD CESARI, Proprietrix,
 Of Birnam Hotel, Birnam, Dunkeld.

BORROWDALE HOTEL,

DERWENTWATER LAKE, KESWICK.

PATRONISED BY THE DUKE AND DUCHESS OF WESTMINSTER. The above old-established Family Hotel and Boarding House is charmingly situated at the Head of Derwentwater, in the picturesque Vale of Borrowdale, amidst the Most Romantic Scenery of the Lake District. It has been refurnished throughout. The Lavatories and Sanitary arrangements entirely renovated. Omnibus meets all Trains, also Coaches from Windermere and Ambleside. Charges per Week, £2 10s.

Posting, Fishing, Boating, and Yachting.

Post and Telegraph Office in Hotel. MRS. EDWARD CESARI, PROPRIETRIX.
 And of Birnam Hotel, Birnam, Dunkeld.

An advertisement for the Ladore Hotel (and other neighbouring establishments), emphasising the romantic beauty of its surroundings, from the 1901 edition of *Miller's Official Tourist Guide to the North British Railway*.

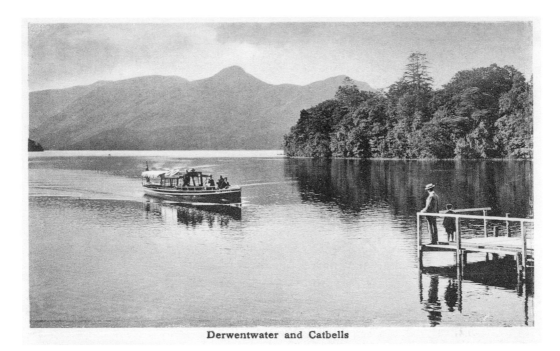

Derwentwater and Catbells

A little way down the western shore of Derwent Water – within easy walking distance of the Ladore Hotel – is the 1,481ft hill known as Cat Bells, a popular climb for beginners and families in Lakeland. The name is thought to derive from the Norse word 'bield', meaning den; i.e. 'the lair of a wild cat'. (*Publisher unidentified*)

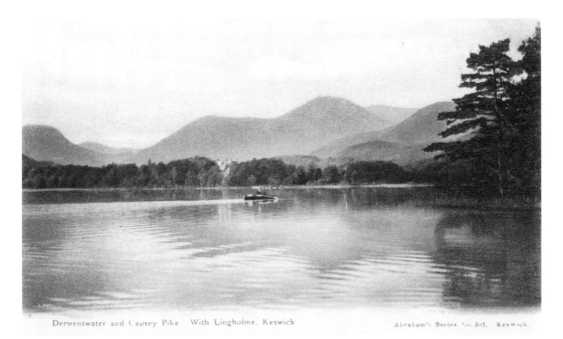

Derwentwater and Causey Pike With Lingholme, Keswick Abraham's Series No. 302. Keswick.

Further down the lake – still to the west – can be seen the more impressive (at 2,035ft) Causey Pike, not directly accessible by road but often tackled as part of a long 'out and back' walk from Keswick. (*Abraham's Series No. 302. Keswick*)

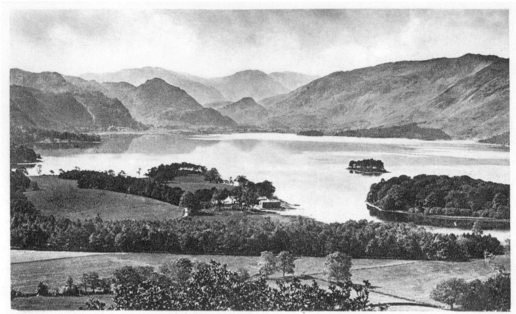

DERWENTWATER FROM CASTLE HEAD, KESWICK

The view south-westwards up Derwent Water from the 529ft Castle Head, a remnant of an ancient volcano just south of Keswick. The island far right is Lord's Island and the one beyond it Rampsholme Island, both National Trust properties. *(G.P. Abraham, Ltd. Keswick)*

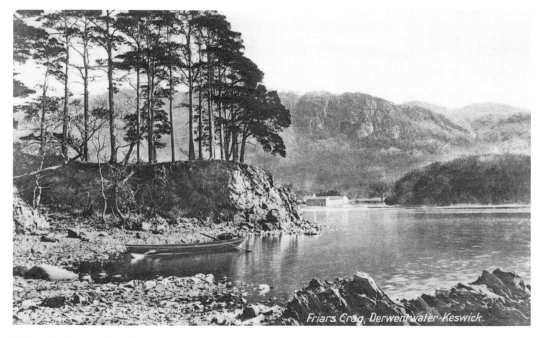

Friars Crag, Derwentwater-Keswick.

Below Castle Head on the lake is Friar's Crag, a popular beauty spot, with the National Trust-owned Derwent Island just offshore. *(Nature-Colour Postcard)*

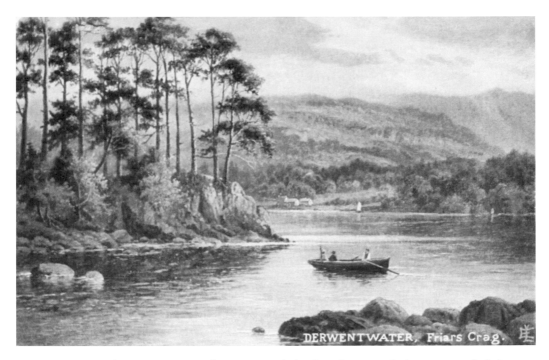

Friar's Crag again, this time as an artist's painting with the three figures in the boat giving a little human interest to the scene. In the Middle Ages pilgrims embarked here to visit the hermit living on St Herbert's Island to the south, hence the promontory's name. *(Boots Cash Chemists "Pelham" Series)*

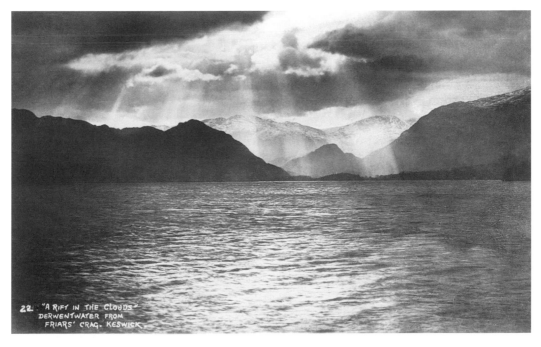

Friar's Crag during – or after – a storm. Fittingly, the sender has written: 'We went on a tour of 8 lakes today but it poured with rain, so we couldn't see much. It is lovely up here.' *(G.P. Abraham Ltd., Keswick)*

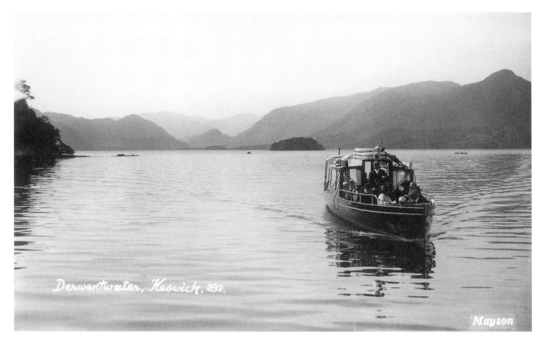

Derwent Water in rather more pleasant conditions, with a motor launch party making the most of the fine weather. *(Maysons. Keswick)*

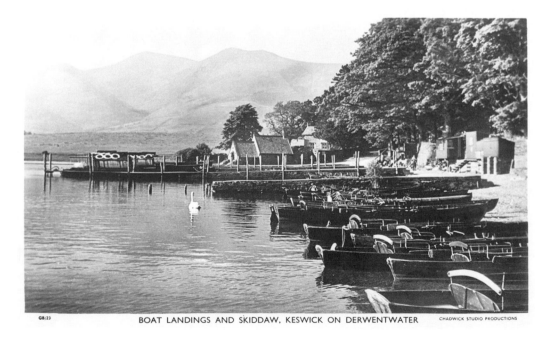

And so to Keswick, at the northern end of Derwent Water, with the Skiddaw massif rising to 3,053ft in the north. *(Chadwick Studio Productions 491, Oakwood Lane, Leeds 8)*

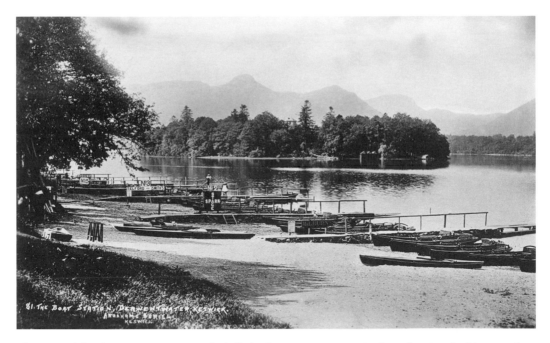

The Keswick landing stages again, with skiffs for hire once more to the fore, this time looking south to Derwent Island, on a 1933-franked photographic card. *(G.P. Abraham Ltd, Keswick)*

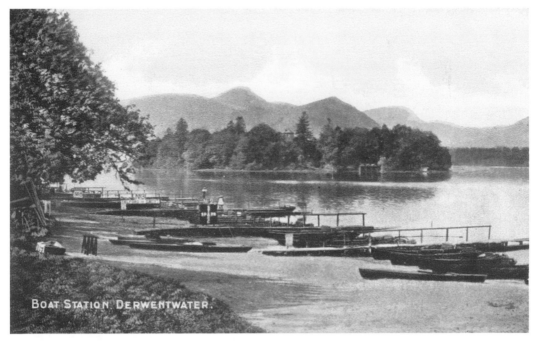

A postcard curiosity: a colour-tinted rendering of the exact same photograph but issued by a different publisher – whether under licence or as a blatant act of plagiarism is not known. *(The Art Publishing Co. Glasgow)*

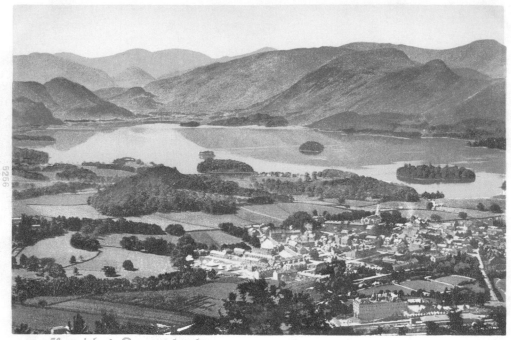

Keswick & Derwentwater.

As this card shows, the town of Keswick is sited a little way inland from its landing stages in the bay on the far right. *(Publisher unidentified)*

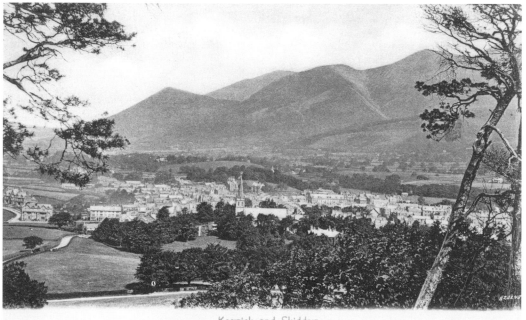

Keswick and Skiddaw.

Looking over the town in the opposite direction, northwards to Skiddaw. *("Clark's Series, Keswick.")*

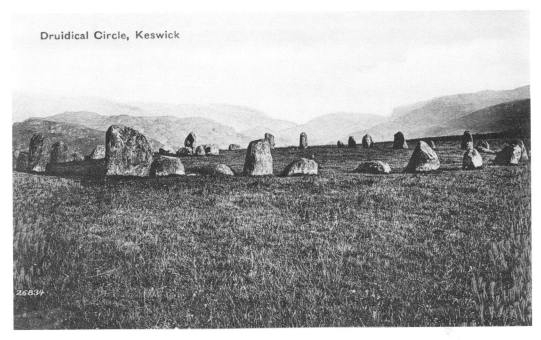

Druidical Circle, Keswick

About 2 miles east from Keswick is Castlerigg Stone Circle. Some 4,000–5,000 years old and comprising nearly forty great stones set on a plateau, it is the Lake District's most impressive ancient monument. Its original purpose is at best a matter for speculation. *(Publisher unidentified)*

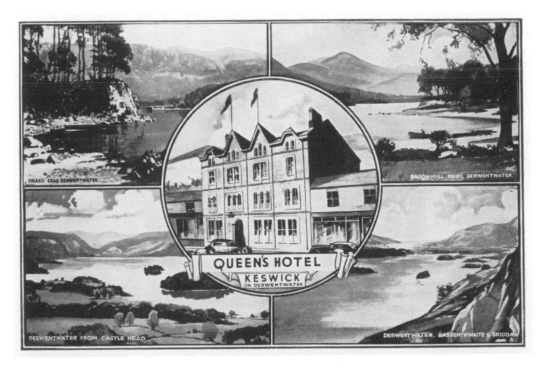

Unusually, a multi-view card produced as a hotel souvenir – in this case for Keswick's centrally located Queen's Hotel – featuring scenes from the area as well as a prominent picture of the impressive building itself. *(W.H. Moss & Sons, Ltd., Whitehaven)*

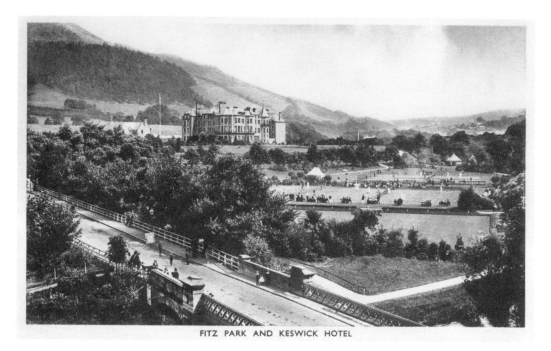

FITZ PARK AND KESWICK HOTEL

Two cards featuring another of the town's grand hotels, the Keswick Hotel (still open, like the Queen's), seen here from across Station Road . . . *(Photogravure Series by G.P. Abraham, Ltd. Keswick)*

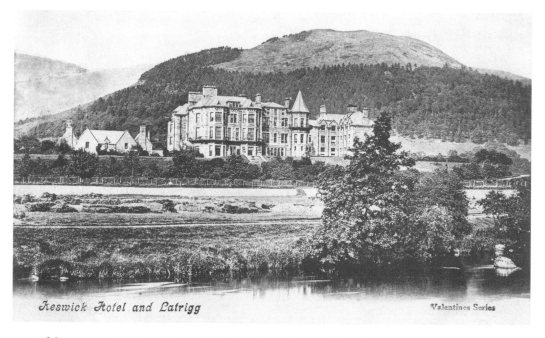

Keswick Hotel and Latrigg Valentines Series

. . . and from across the River Greta, which flows into the town from the east to join the River Derwent after the latter leaves the lake. The smaller building to the left is the railway station (opened in 1865 and closed in 1972), now incorporated into the hotel. *(Valentines Series)*

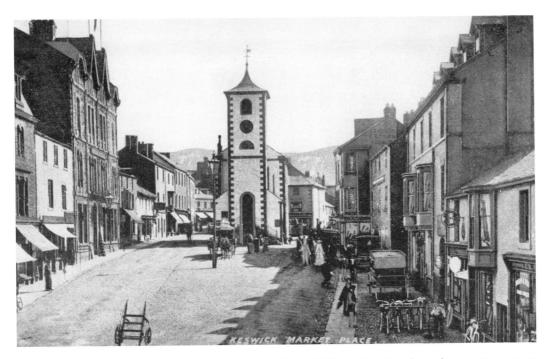

The town of Keswick boasts a market charter dating from 1276, and has long been the most important commercial and tourist centre in the northern half of the Lake District. This is the Market Place, in the 1900s, looking to the 1813 Town Hall and prison, known as the Moot Hall. *(A Pettitt, Keswick)*

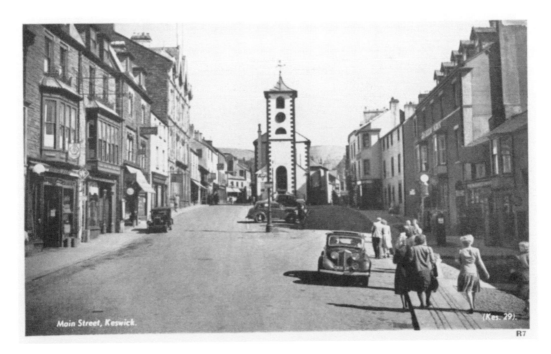

The same scene thirty years on, showing little by way of change in the buildings – but much as regards vehicles and fashions. Today, further changes will be evident to the visitor: the street has been pedestrianised and the Moot Hall is now an information centre. *(The Westmorland Gazette, Ltd, Kendal)*

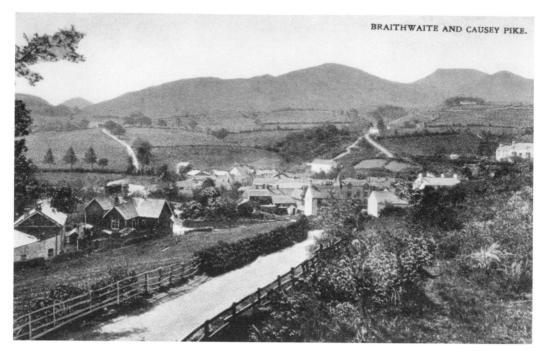

About 2 miles west of Keswick, on the A66 to Cockermouth, is the village of Braithwaite, an excellent centre for walkers offering a good selection of fells to the west and (like Causey Pike) to the south. (*Clark's Series, Keswick*)

Between Braithwaite and Cockermouth lies Bassenthwaite Lake, 4 miles long but only 70ft deep, making it one of the shallowest of the lakes. It is in fact the only one to bear the name of 'lake' – though just to confuse matters, Wordsworth knew it as Broadwater! (*Phillip G. Hunt, Printer, London*)

7

Ullswater & Haweswater

'I never saw daffodils so beautiful, they grew among the mossy stones
about and about them, some rested their heads upon these stones, as on
a pillow, for weariness and the rest tossed and reeled and danced and
seemed as if they verily laughed with the wind that blew upon them over the
lake, they looked so gay ever glancing ever changing.'

(Dorothy Wordsworth, *Grasmere Journal*, 15 April 1802)

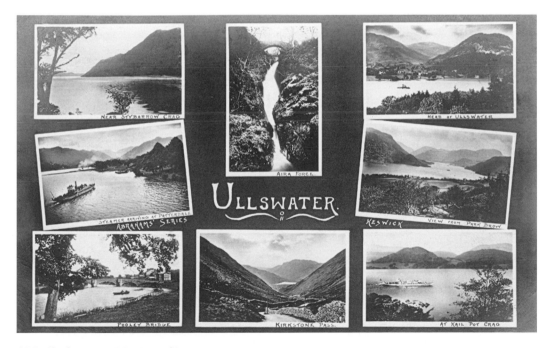

(G.P. Abraham, F.R.P.S., Keswick)

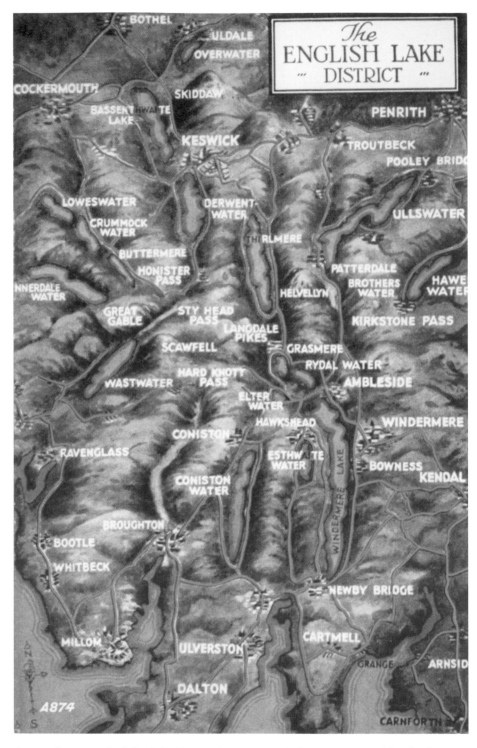

A second map card of the Lake District (compare with the one on page 7) only this time
an artist's colour rendition in portrait rather than landscape format – neither of which,
however, can do full justice to the pattern of the lakes in relation to the adjacent coastline.
(*"Art Colour" Postcard. Valentine & Sons, Ltd., Dundee and London*)

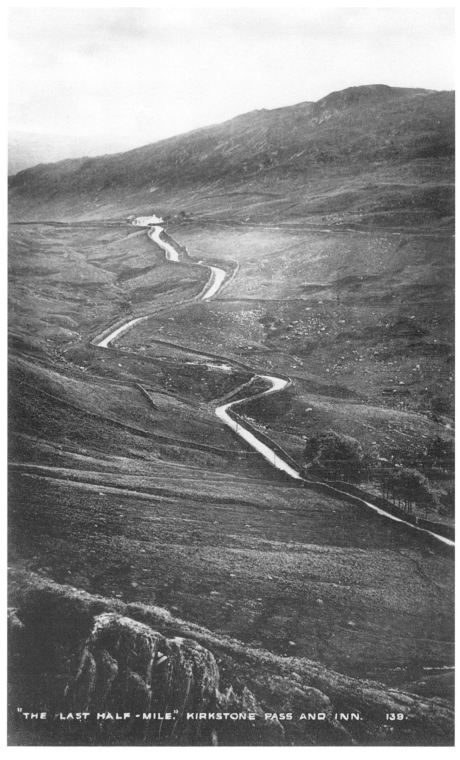

"THE LAST HALF-MILE." KIRKSTONE PASS AND INN. 139.

The final leg of our journey round the Lake District begins with the road north from
Windermere over the Kirkstone Pass – the highest pass in the Lake District – to Ullswater.
(G.P. Abraham, Ltd., Keswick)

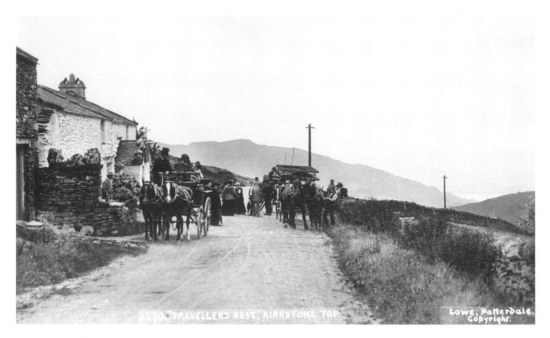

At the 1,489ft summit of the pass is the Kirkstone Pass Inn (glimpsed in the distance on the previous card), then as now offering the chance of a welcome rest to weary or wet travellers. *(Lowe, Patterdale)*

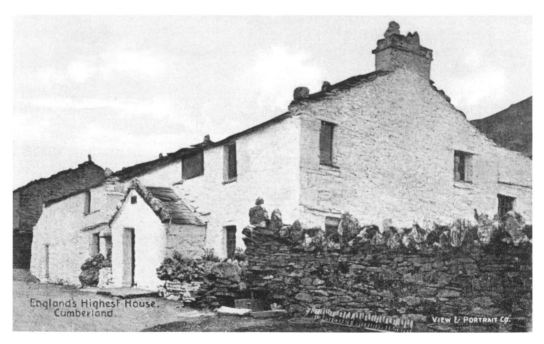

Dating from 1496, the inn is the highest in Cumbria. Whether it ever was England's highest house, as this 1907-franked card claims, is a matter which we shall perhaps never resolve. *(View & Portrait Co.)*

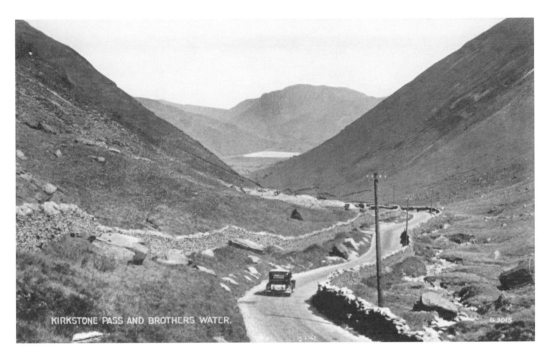

KIRKSTONE PASS AND BROTHERS WATER.

Roughly halfway down the long descent from the Kirkstone Pass Inn to the southern end of Ullswater is the tarn known as Brothers Water, here seen in the distance. *("Photo Brown" Postcard, Valentine & Sons, Ltd., Dundee and London)*

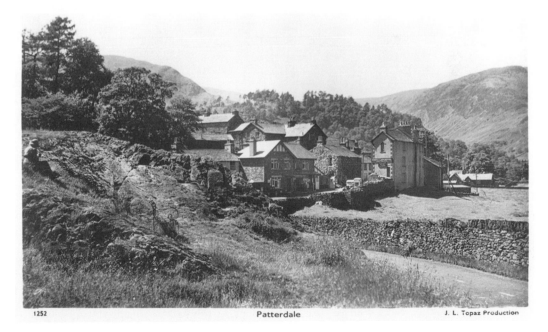

1252 Patterdale J. L. Topaz Production

At the bottom of the Kirkstone Pass, beyond Brothers Water, the road reaches the village of Patterdale, situated on what is now the A592 on the west bank of the Goldrill Beck (off to the right) meandering its way towards Ullswater. *(J.L. Topaz, Penrith)*

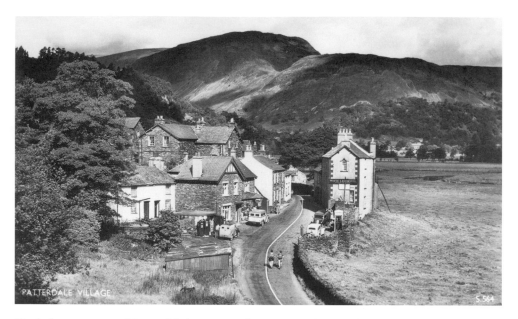

Much the same view of Patterdale but now in the 1950s, with the Goldrill Beck visible to the right. Note the two hikers undisturbed by traffic on the main road – today such walkers are likely to be doing the Coast-to-Coast Long Distance Footpath, which runs through the village. *(Sanderson & Dixon, Ambleside)*

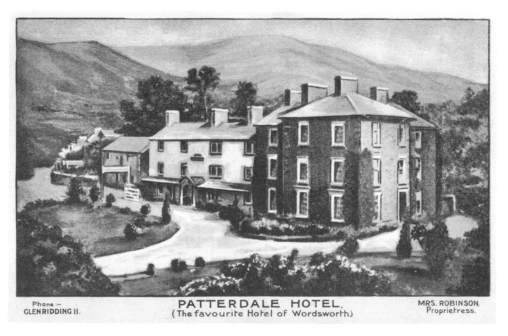

The Patterdale Hotel, another of the Lake District's long-serving establishments and one ideally positioned as a base from which to scale Helvellyn to the west. The name Patterdale is thought to be a corruption of Patrick's Dale, the Irish saint reputedly having preached and baptised here. Note the claimed Wordsworth connection on this postcard from about 1920 – always a good selling point for a Lakeland business! *(Publisher unidentified)*

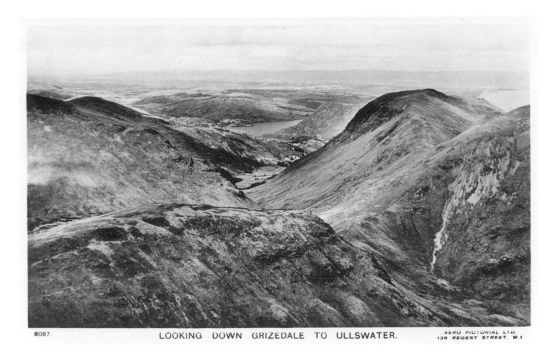

8087. LOOKING DOWN GRIZEDALE TO ULLSWATER. *AERO PICTORIAL LTD.* / *136 REGENT STREET, W.1*

North of Patterdale the Goldrill Beck is joined from the west by Grisedale Beck just before it enters Ullswater. Note the spelling mistake in the caption: Grizedale lies between Esthwaite Water and Coniston Water. *(Aero Pictorial Ltd. 136 Regent Street, London, W.1)*

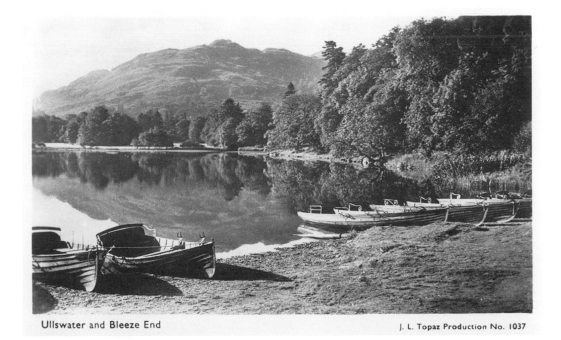

Ullswater and Bleeze End J. L. Topaz Production No. 1037

The combined becks – behind the camera – enter Ullswater at its southernmost tip, Bleeze End. This view is north-eastwards to the isolated peak of Place Fell. *(J.L. Topaz, Penrith)*

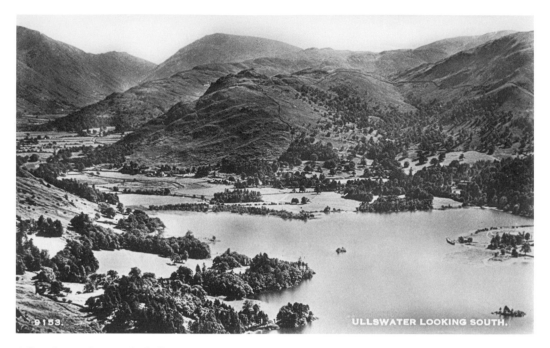

Still at the southern end of Ullswater, this time looking from the opposite direction from high up on Silver Crag. The Kirkstone Pass disappears into the mountains on the top left of the picture. (*"Aero Pictorial Ltd., 137, Regent Street, London, W.1"*)

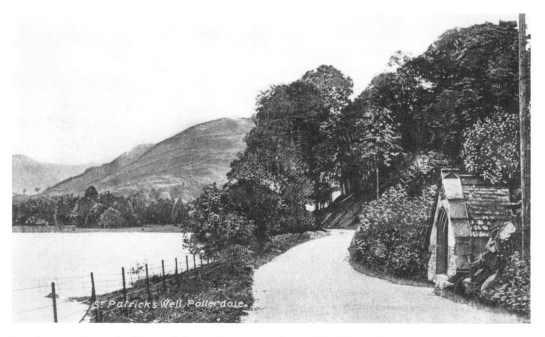

Less than a mile north of Patterdale, on the western shore of the lake, is the southern steamer terminus of Glenridding; between the two villages is St Patrick's Well – a natural spring reputed to have healing powers, and where the saint is said to have baptised converts to Christianity. (*The Art Publishing Company Glasgow*)

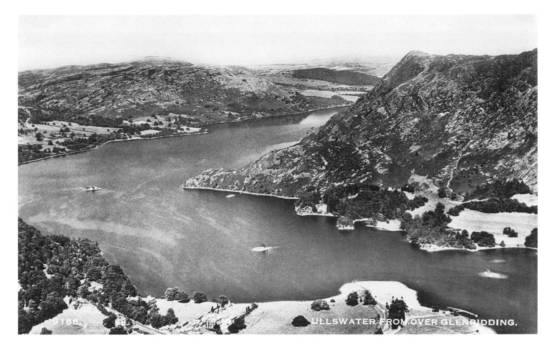

Ullswater is the most twisted in shape of all the lakes. This is the view from above Glenridding, looking north-eastwards. *("Aero Pictorial Ltd., 137, Regent Street, London, W.1")*

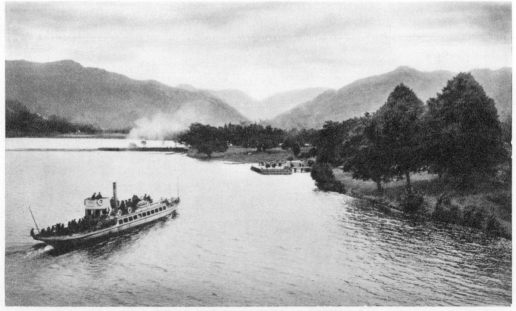

The Ullswater Navigation & Transit Co.'s twin-screw steamer *Raven* – captioned as a steam yacht – arriving at Glenridding Pier (not Patterdale) on a round trip from the northern end of the lake. *(G.P. Abraham, Ltd. Keswick)*

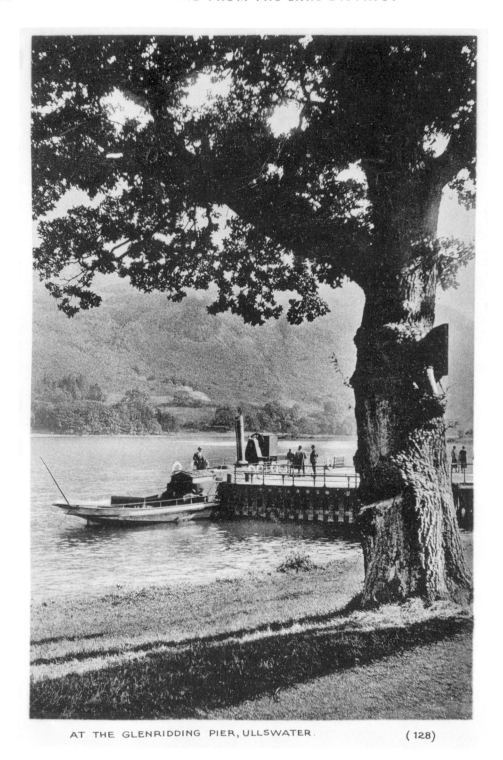

AT THE GLENRIDDING PIER, ULLSWATER. (128)

The little pier at Glenridding village, by the Ullswater Hotel, with the *Raven* now docked. Built in 1889 by Seath of Rutherglen, she is 112ft in length with a beam of 15ft. Converted from steam to diesel propulsion in 1935 she is still in active service, along with her sister vessel the *Lady of the Lake*, more than 120 years later. *(Reed's "Supertone" Series. Reed's Ltd, Penrith)*

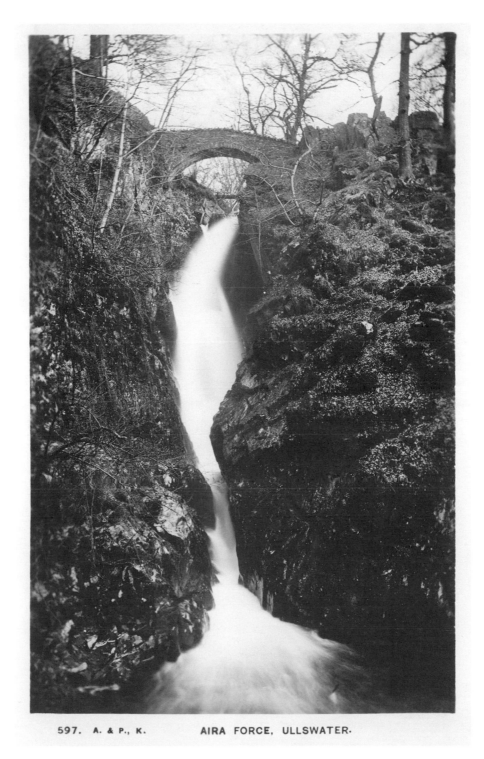

597. A. & P., K. AIRA FORCE, ULLSWATER.

After the lake swings round to the east, Ullswater is joined on its northern shore by the Aira Beck dropping down off the fells. Its lower, dramatic waterfall Aira Force, with its 70ft drop beside the A5091, is perhaps the most famous of all the Lakeland forces. (*Atkinson & Pollitt, Kendal*)

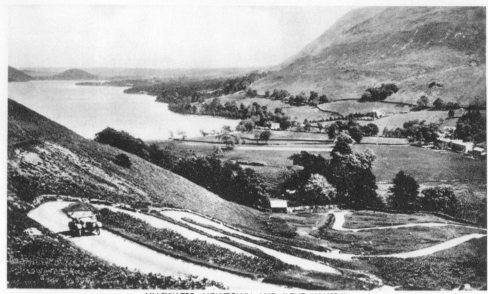

ULLSWATER, HOWTOWN AND " THE HAUSE "

Two miles further down Ullswater, on the opposite, southern shore, is the steamers' intermediate stopping-place of Howtown. Here its minor road link to the northern end of the lake forsakes the shore to wind up to the scattered farmsteads on the fells above – a drive most definitely not for the faint-hearted! *(G.P. Abraham, Ltd. Keswick)*

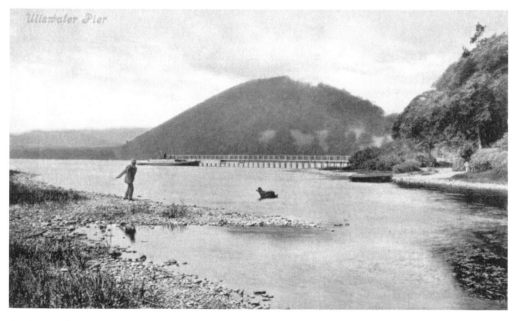

At the northern end of Ullswater is Pooley Bridge where the lake is drained by the River Eamont flowing out of the National Park towards Penrith. This is the steamer pier, with the *Raven* again – and a man engaged in the age-old pastime of throwing sticks for his dog. This card was seemingly purchased as a holiday souvenir for it was posted, in 1910, in New York to a New York address – since when it has somehow made the return trip across the Atlantic. *(Valentine's Series)*

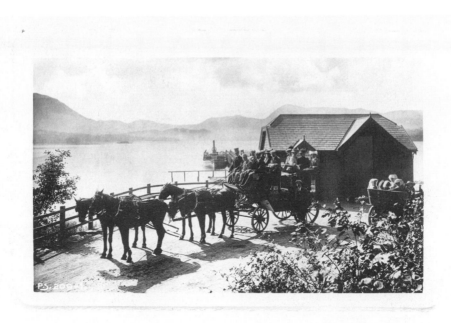

ULLSWATER, POOLEY BRIDGE

The pier approach, Pooley Bridge, on a 1909-franked card, with a party of holidaymakers, fresh off the steamer in the background. They are in the care of a liveried coachman, perhaps bound for a nearby hotel or hostelry? *(The Rapid Photo Printing Co., Ltd., London, E.C.)*

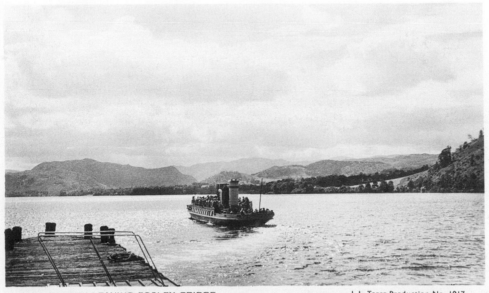

THE "RAVEN" LEAVING POOLEY BRIDGE J. L. Topaz Production No. 1017

An atmospheric evening photograph of the *Raven* leaving Pooley Bridge on a 1950-franked card. Her superstructure was remodelled in 1935, at the time the new engines were fitted, giving the vessel a markedly different appearance. *(J.L. Topaz, Penrith)*

ULLSWATER

"The English Lucerne."

The Royal Mail Steam Yachts

Of the Ullswater Steam Navigation Company, Limited, will ply on Lake Ullswater (weather permitting and Sundays excepted), from April 4th to September 30th, 1901.

STEAMBOAT FARES.

BETWEEN.		Single Fare. 1st Cl. s. d.	2nd Cl. s. d.	Return Fare. 1st Cl. s. d.	2nd Cl. s. d.
Pooley Bridge and Howtown,	- -	1 0	0 9	1 6	1 3
Howtown and Patterdale,	- - -	1 6	1 0	2 0	1 6
Pooley Bridge and Patterdale,	-	2 0	1 6	3 0	2 0

Children under 12, half price.

Pleasure Parties of not less than Ten will be taken at Half Return Fare for the Double Journey, on One Day's Notice being given to the Secretary or Captain, except by the Boats leaving Patterdale at 1.40 p.m., and Pooley Bridge at 2.55 p.m. Season Tickets, £1. Weekly Tickets—First Class, 6s. 6d.; Second Class, 4s. 6d. Not transferable.

COACH FARES.

Between Penrith and Pooley Bridge—Single Tickets, 2s.; Return Tickets, 2s. 6d. (Coachman's fee included.)

Coaches for Ullswater leave Ambleside, Bowness and Windermere, daily during the season. Fares from Ambleside—Single, 3s. 6d. and 4s.; Return, 5s. From Bowness and Windermere—Single, 6s.; Return, 8s. 6d. Fares from Ullswater (Patterdale) to Ambleside—Single, 5s.; Return, 6s. 6d.

TRAIN SERVICE.

The following Railways afford communication with Ullswater by Express Train Service to Penrith (the Station for Ullswater), viz.:—London and North-Western Railway; Caledonian Railway; North-Eastern Railway; Midland Railway (via Appleby); Great Northern and Great Eastern (via York and Darlington); and the Great Western Railway, Lancashire and Yorkshire Railway, Great Central Railway, North-British Railway, Glasgow and South-Western Railway, in conjunction with the London and North-Western Railway.

Tourist and Week-end Tickets to Penrith are issued at the principal Stations of the above lines. The holders of Tourist Tickets to Scotland on the London and North-Western System are allowed to break their journey (either way) at Penrith, in order to visit Ullswater.

Circular Tour Tickets, embracing Ullswater, are issued on C. K. & P. (from Keswick and Cockermouth), and L. & N.-W. and Furness Railways. For particulars of which see the Railway Company's Tourist Programme.

Guide to Ullswater. Illustrated. Post free, 4d.

For further information see the Company's Time Tables and Sailings Bill, or apply to

WILLIAM SCOTT, Sec. U.S.N.Co., Public Offices, Penrith.

A final advertisement from *Miller's Official Tourist Guide to the North British Railway*, this time for the Ullswater Steam Navigation Co. Ltd's summer season (4 April to 30 September) 1901, giving first and second class steamer fares, plus connecting coach service details and other information deemed useful for prospective visitors to the lake. Note the 'English Lucerne' epithet: guide books of this period regularly compared the scenery of England to that of Switzerland in a blatant attempt to stop travellers from venturing across the Channel.

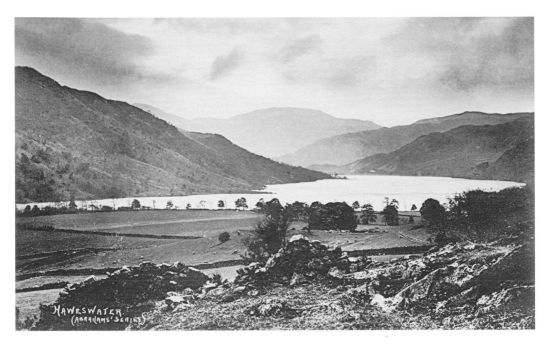

The last of the sixteen lakes is Haweswater, some 2½ miles long and 102ft deep – or so it *was*, for in 1940 the Manchester Water Corporation constructed a dam at its northern end, converting it into a 4-mile-long, 198ft-deep reservoir, the most radical man made reshaping of any of the lakes. *(G.P. Abraham, F.R.P.S. Keswick)*

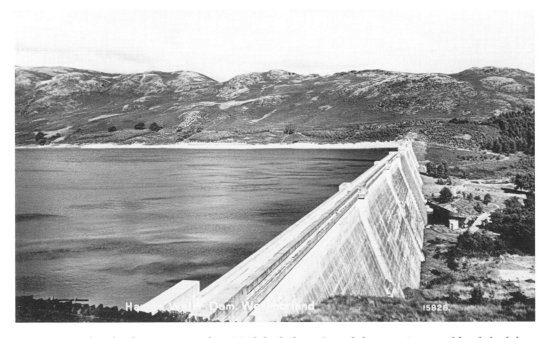

Haweswater after the damming – and its 120ft-high dam. One of the most inaccessible of the lakes, and well off the beaten track, it is nevertheless still well worth a visit, and a fitting end to our tour. *(Publisher unidentified)*

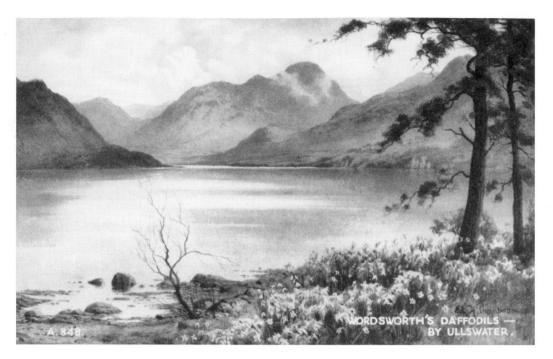

If not Wordsworth's daffodils then surely their descendants, for it was on 15 April 1802 that such a sight, where Gowbarrow Park meets the north-western shore of Ullswater, inspired him to compose his most famous poem. *("Art Colour" Postcard. E.H. Thompson, A Lakeland Artist. Valentine & Sons, Ltd., Dundee and London)*

> I wandered lonely as a Cloud
> That floats on high o'er Vales and Hills,
> When all at once I saw a crowd
> A host of dancing Daffodils;
> Along the Lake, beneath the trees,
> Ten thousand dancing in the breeze.
>
> The waves beside them danced, but they
> Outdid the sparkling waves in glee: -
> A poet could not but be gay
> In such a laughing company:
> I gazed - and gazed - but little thought
> What wealth the shew to me had brought:
>
> For oft when on my couch I lie
> In vacant or in pensive mood,
> They flash upon that inward eye
> Which is the bliss of solitude,
> And then my heart with pleasure fills,
> And dances with the Daffodils.

William Wordsworth, 'I wandered lonely as a Cloud' (original 1807 version)